FRANCISCO GOYA
PAINTINGS, DRAWINGS AND PRINTS

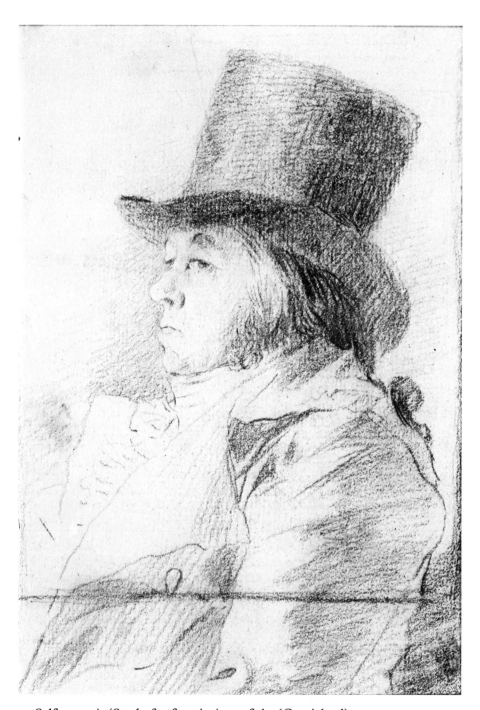

1. Self-portrait (Study for frontispiece of the 'Caprichos'), *c.* 1797
Red chalk, 177 × 127 mm. New York, The Walter C. Baker Collection of Drawings

Francisco Goya

PAINTINGS, DRAWINGS
AND PRINTS

Selected and introduced by
Philip Troutman

The Folio Society
London 1971

PRINTED IN GREAT BRITAIN
Printed and bound by Jarrold & Sons Ltd, Norwich
Set in 'Monotype' Plantin type
Printed throughout by photo-lithography

Introduction

Francisco de Paula José Goya was born on 30 March 1746 in the small village of Fuendetodos, near Saragossa. His parents were citizens of the Aragonese capital and their temporary presence in Fuendetodos, where his mother had relations and some property, may have been due to his father's trade as master-gilder. It is from his schooldays that we have the first report of his talent for drawing, which prompted his father to place him for four years with the painter José Luzán, who had been trained in Italy and ran the most important school of drawing in Saragossa. In 1763, on completion of his training with Luzán, Goya entered a competition for a scholarship at the newly founded Royal Academy of Fine Arts and failed to obtain one vote in his favour. After again entering a competition at the Academy three years later with the same unpromising outcome, he appears to have spent some time in Madrid with the painter Francisco Bayeu, a fellow Saragossan, twelve years his senior.

Towards the end of the 1760s, Goya, like many another young artist of his time, made the journey to Rome, where he entered a competition held by the Parmese Academy, but again with no success.

In the autumn of 1771 he was back in Saragossa to carry out his first really significant commission, the painting of the *Adoration of the Trinity* in the vault of the '*Coreto*', or 'little choir', of the Cathedral of El Pilar, which was to be followed by other important commissions for religious paintings in the town. In 1773 he married Francisco Bayeu's sister, Josefa. In spite of Bayeu's patent inability to appreciate Goya's art, and his misdirected attempts to interfere in his painting as his sponsor and erstwhile tutor, which were to lead to some embitterment on Goya's part, it is clear that he did much to further the professional career of his brother-in-law, stubbornly concerned with his art as opposed to the wishes of his prospective clientele.

Goya's first real opportunity came in 1776, when he was thirty years of age. Mengs had returned to Madrid in 1774, and one of his tasks was the reorganization of the Royal Tapestry Factory, founded in 1720 by Philip V in emulation of the Gobelins. Through Bayeu, Goya was chosen to be one of the artists to paint the full-size cartoons for the tapestries destined to decorate the apartments of the royal palaces. The first cartoons painted by Goya, in 1775, represented subjects of the chase, of appeal to Charles III, the 'Hunting King'. In the following year the subject-matter of the tapestries was changed, in conformity with a growing interest in the popular, and the tapestries were henceforth to depict the costumes and diversions of the time'.

Goya was immediately to make the new subject-matter his own, as he set himself to observe and record the character and behaviour of the people around him. He had clearly misconstrued the real intention of the designs, which was to provide an entertaining decoration. Goya deviated too in another way: his painting was too free and he was soon to have one of his cartoons returned, for the weavers had difficulty in reproducing the 'changing tones'.

In 1778 he made acquaintance with Velazquez's paintings in the royal collection, making copies of all of them in his first series of etchings (No. 43). This was a painter with whom he could have some sympathy: Velazquez belonged to the all-but-forgotten Spanish tradition, and he too had concerned himself with the portrayal of the human individual and had developed a style of painting of incredible freedom.

In January 1780, work on the tapestries was suspended for reasons of economy, and Goya suddenly found himself without any official employment. The succeeding five years were spent in seeking the needed patronage for his art, and at this time he appears to have made some concessions. In 1780, he submitted his Bayeuesque *Crucified Christ* to the Academy and was unanimously elected a member. Later in the year, under Bayeu's supervision, he started work on a further fresco decoration for the Cathedral of El Pilar in Saragossa, the *Virgin as Queen of the Martyrs*, which gave rise to a few years of estrangement between the two artists, the authorities objecting to the freedom of the painting, and Goya refusing to make any adjustments. In 1783 he made a rather pretentious and Mengs-like portrait of the First Minister, Floridablanca, in which he introduced a portrait of himself somewhat obsequiously submitting a painting to his potential protector; but to no avail. Later in the same year he stayed at the country estate of the ex-Cardinal Infante Luis, where he painted the portraits of the individual members of the Prince's family and a group portrait, in which he again introduced a portrait of himself as a would-be member of the Prince's household. In December 1784 a son was born to Josefa and José Goya, the only child of theirs to survive.

Goya's efforts to gain protection finally bore fruit in 1785, in which year he found in the Duke of Osuna a generous and sympathetic patron (No. 4). In the same year he was elected Deputy Director of Painting at the Academy, where his brother-in-law held the post of Director; and in the following year, on the recommendation of Bayeu, he was nominated one of the Painters to the King (*Pintor del Rey*) for the specific task of resuming work on the tapestry cartoons. He was forty years of age, and for a moment we find him relaxed. He tells Martin Zapater, his friend from schoolboy days with whom he kept up a protracted correspondence, of his contentment and of his gratitude to Bayeu.

But his contentment was to be short-lived. There was not time to carry out the countless commissions that now came to him and he was anxious to work on his own painting; he would make no concessions, but could not afford to displease his patrons. He confides this to Martin Zapater, and we sense an imminent breakdown.

Charles III had died in 1788, and in the following year, on the accession of Charles IV, Goya was nominated one of the Painters to the Chamber (*Pintor de Cámara*). He promptly resisted working on the tapestry cartoons, and when urged to resume work replied that it was not an occupation proper to a Painter of the Chamber; that is, Goya saw his

new advancement as a sign of confidence in him as an artist, and as such, it should carry with it no impositions. It is hardly possible that such an attitude could have been appreciated by his patrons. After the intervention of Bayeu, Goya repented, and in the summer of 1791 he resumed work on the cartoons for the tapestries, producing in a year of feverish activity a whole series of immensely original designs in which he seems to have made the definitive step to paint in his own way. The turn of events in neighbouring France, of which the Spanish Bourbon Court were only too aware, also appear to have inspired a greater seriousness and urgency in Goya's painting.

In the autumn of 1792, on the conclusion of what was to be his final work for the Royal Tapestry Factory, Goya fell seriously ill. He partially recovered in the following year, but was left permanently deaf. His deafness possibly made him even more sensitive to the social atmosphere and even more determined to make no concessions in his art. In 1795, on the death of Francisco Bayeu (No 8), Goya was elected his successor in the post of Director of Painting at the Academy. During the few years to 1798, when he was still convalescing, the King made no demands on his services, and Goya was left comparatively free to devote himself to his own art. It was in these years that he came to know the Duchess of Alba. In 1795 he had made the portraits of the Duke and Duchess (No 9), and after the death of the Duke in the following year he was invited by the Duchess to stay at her estate in Andalucia, where in 1797 he again painted her portrait. This portrait and an unpublished plate of his famous engraved series of the 'Caprichos' (Nos 44–50), of the same year, make it clear that Goya was deeply infatuated by the Duchess. The legend that tells of the Duchess sitting for the paintings of the *Clothed* and *Unclothed Maja* (Nos 10 & 11) at the time the Duke was alive is impossible, since the paintings were made some years after the Duke's death and most probably after the Duchess's death in 1802. The sitter also bears little resemblance to the Duchess as we know her from the two portraits Goya made of her. Nevertheless, his experience – it was most likely a one-sided affair – must have had an influence on his interpretation of the theme of woman.

By 1798 Goya had sufficiently recovered from his illness to carry out the fresco decoration of the newly built Neo-classical Church of San Antonio de la Florida in Madrid, the first royal commission he had received since his illness. The painting is one of the most original and splendid testimonies of his genius, and the church is now appropriately Goya's Pantheon. In the following year Charles IV nominated Goya his First Painter to the Chamber (*Primer Pintor de Cámara*). He now held at the Academy and the Court the two highest posts to which a painter could aspire. 'The sovereigns are mad about your Goya!' he writes to Martin Zapater. One of the immediate outcomes was the famous portrait of the *Family of Charles IV*, one of Goya's most brilliant displays of painting; and to the following decade belong a whole series of splendid portraits, specially of women, including the two *Majas*.

In 1808 came the invasion of Spain by Napoleon's forces, the implantation of the 'usurper' king, Joseph Bonaparte, on the Spanish throne, and the subsequent years of war and famine. The events inspired Goya's famous engraved series of the '*Disasters of War*' (Nos 51–61), of 1810, and the two great masterpieces of painting, the '*Dos de Mayo*' and '*Tres de Mayo*' (Nos 17 & 18), painted after the conclusion of the war in 1814. His wife, of whom we hear so little, had died in 1812.

On the return of Ferdinand VII to the Spanish throne, Goya was confirmed in the positions he held at the Court and Academy. He had first to be cleared of collaboration with the French, and during the occupation he had painted a portrait of the usurper King for the Town Council of Madrid, although after the liberation of Madrid in 1812 he had also painted Wellington's portrait. The Inquisition had returned with Ferdinand, and Goya was also commanded by that body to explain the circumstances of his paintings of the *Majas*, two of 'four obscene paintings' (the others included, apparently, Velazquez's famous *Venus* in the National Gallery) found among the sequestrated property of Charles IV's Chief Minister, Godoy. It would be very interesting to know the circumstances of the paintings, but unfortunately the records have not come to light. The war was over, Goya had been 'purified' and confirmed in his posts, and for a moment he could feel he could relax. In 1815 he prepared his engraved series of the *Tauromaquia* (No 63).

He could not relax for long, however. Following close upon the vast desolation left by the war came further years of tragedy. Ferdinand had renounced the popular Constitution that he had sworn to uphold on his reinstatement to power, and he and the Inquisition were determined their authority should not be threatened by liberal thought. A reign of oppression and persecution followed. Countless men of liberal sympathies, including a number of Goya's friends, fled the country. The garrotte and gallows were in evidence enough in the land, but the outrage was of a different kind from that of the war against a foreign usurper, and Goya's painting underwent a corresponding change.

In 1819 the ageing artist purchased a country-house on the outskirts of Madrid, where perhaps he hoped to spend his last years in peace. This was the '*Quinta del Sordo*' ('House of the Deaf Man'), as it was popularly called, which he decorated with his famous 'Black Paintings' (Nos 20–22) now in the Prado Museum. He had suffered another serious illness – possibly a recurrence of his earlier one – towards the end of 1819, and the paintings were made after his recovery in the following year and before September 1823, when he made over his country-house to his grandson Mariano 'as a proof of his affection'. It is likely he already had ideas of leaving Spain, for in 1823, after an interim of constitutional government, the King, with the aid of a French army, returned to absolute power, and a new reign of terror began. Goya took refuge in the house of a friend, and in May 1824, taking advantage of a short amnesty, he asked permission to take the waters at Plombiéres in France 'for the sake of his health'. The King granted his permission and Goya left Spain. He did not, however, go to Plombiéres, but to Bordeaux, where he joined some of his friends in exile. One of these friends, Moratín, describes Goya's arrival in that city: 'Goya has arrived, aged, deaf and weak, and without a word of French, but is very content and anxious to see everything.' He made a short trip to Paris, and returned to Bordeaux, where he stayed with his housekeeper, Leocadia Weiss, and her daughter, Rosario, to whom he gave drawing lessons. His hand was weaker and his eyesight failing, but he was active to the end. On 16 April 1828, shortly after his eighty-second birthday, the great Spanish painter died in exile.

Contents

Paintings

Goya lived through a time of social crisis, and his art, which was infinitely responsive to the constantly changing social atmosphere, was concerned exclusively with the portrayal of the individual in society.

It was only after a long struggle that he finally arrived at his own painting. The development of his painting to around 1791 depended upon a gradual deviation from the styles he had early mastered – the Baroque, Rococo and Neo-classical – as he introduced some new conception of form, rhythm and painting of his own.

The delightful portrait of the little *Infanta Maria Teresa* (No 2), one of his earliest essays in portrait painting, clearly recalls Velazquez, but the almost naïve simplicity of the pose is Goya's own. His splendid early masterpiece of religious painting, the *Annunciation* (No 3) of 1785, may owe something to Tiepolo, but the substantial attraction of its colour and the originality of its design is Goya's and foreshadows something of the supreme mastery of colour and design he was later to attain. Goya's very individual sense of design appears with remarkable effect in such paintings as the group-portrait of the *Family of the Duke of Osuna* (No 4) of 1788. The puppet-like character of some of his portraits at this time lends to the simple pose and gesture a certain self-conscious and unwilled quality and gives the figure a special feeling of life and awareness.

There is no abrupt transition from Goya's early painting to his mature painting, but in his startling designs of the *Manikin* and *Pick-a-back* (Nos 5 & 6), of 1791–2, he appears finally to have thrown aside all dependence on tradition. It may be pointed out that these new designs or images do not depend on any distortion: their novelty or spectacular quality, their impressive silhouettes which give a sense of expansion to the forms, may be deviations from the norms of pictorial design, but do not rely on a distortion of the figure.

During the four or five years after the serious illness he suffered at the end of 1792 he took advantage of the consequent, temporary falling-off of commissioned works to apply his new-won freedom to extending his observations and exercising his creative imagination.

His palette changed, and many of his paintings of these years are characterized by a predominance of grey or brown, as he concentrated his attention on developing his images or designs. The first works he produced after his illness are remarkable more especially for their subject-matter (including the *Madhouse* (No 7)). It was also in these years that he made the series of small paintings of witchcraft scenes that dwell on superstitions and irrational beliefs. The culmination of these few years of activity were the eighty immensely original and compelling designs of the engraved series of the *Caprichos* (Nos 44–50), of 1797, which appear finally to have convinced Goya of the infinite power of the creative imagination once it was left free.

The fine portrait he made of *Francisco Bayeu* (No 8) in August 1795, a few days after his brother-in-law's death,

with its emphasis on the broad and simple silhouette, is good example of his painting during this 'grey' period.

The fresco decoration of the Church of San Antonio d la Florida in Madrid, painted in 1798, his greatest master piece of colour and inspired handling up to that date, was t introduce a decade of paintings of unparalleled richness an splendour, including the two *Majas* (Nos 10 & 11), and th *Isabel Porcel* (No 12) in the National Gallery.

With the outbreak of war in 1808 Goya's painting under went a further dramatic change: his colour lost something its splendour and became heavier and more powerful, an the handling of his brush became even more spontaneou and energetic. The new *genre* he introduced at this time labourers engaged in their various activities is distinct fro that of the pictures of manual workers which were to becom popular in the nineteenth century and which no doubt owe something to Goya. The knife-grinder at his wheel, the me digging the soil, preparing gunpowder on the *sierra*, appl themselves to their work with a frenzied compulsion. Whe transferred to the plates of his engraved series of th 'Disasters of War' ('With or without cause' (No 51), 'Th same' (No 52)), they take on a terrifying significance. Th still-lifes he painted during the war are not innocent arrang ments of objects, and they may similarly be related t some of the plates of the 'Disasters' ('*They take advantag from it*' (No 54)). If Goya had earlier observed the inmates the madhouse or prison as part of the social reality, he no contemplated scenes of savages and cannibals, which wer more relevant in the context of the present human violenc

On the conclusion of the war Goya produced two of h most powerful and original paintings, the '*Second of Ma* and '*Third of May*' (Nos 17 & 18). They effect a revolutio in history painting: there is no splendid spectacle, no gran deur, no hero, no celebration of the victory.

During and after the war most of Goya's energies wer spent on paintings made for his own satisfaction or for h friends. The so-called 'Black Paintings', with which he de corated the walls of his country-house in the years 1820 t 1822, constitute the most tremendous monument to h imaginative genius. The images, taken from the Old Testa ment (Judith), classical mythology (Saturn devouring h children), witchcraft and popular genre (the *Witches' Sa bath* (No 21) and the *Pilgrimage of Saint Isidore* (No 22) bring together hitherto distinct *genres* of painting. The de signs are compelling and explicit, the motivations and actio they express are real. If we were to choose Goya's one maste piece from this series it would probably be the monument and terrifying design of the *Duel with Clubs* (No 20), wit the large and haunting image of the two figures silhouette against the sky and the interminable rhythm of the desig There is still no distortion, but Goya's painting and desig knew how to give the scene the tremendous proportions its reality and human implications.

Goya continued to paint portraits in these last years of h life, and among the finest is the *Self-portrait* (No 19) of 181

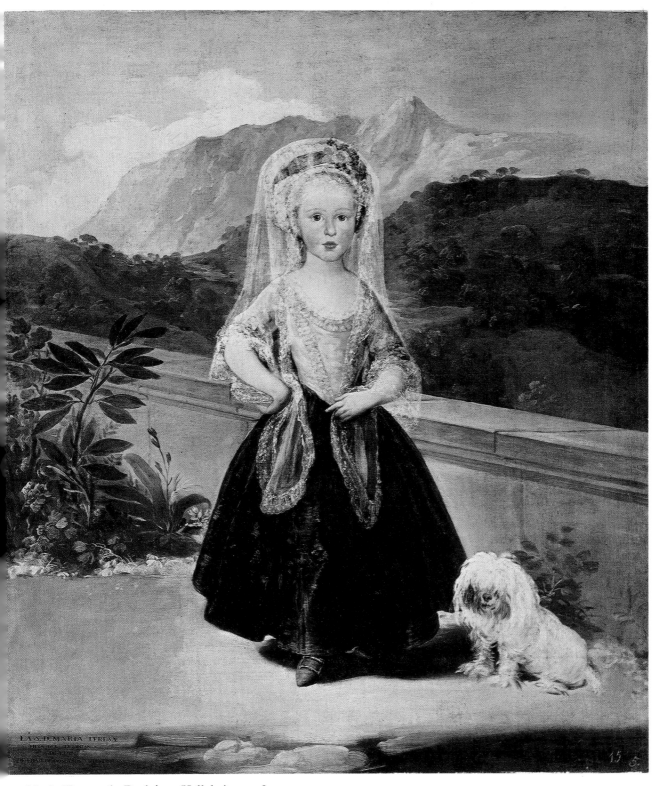

2. Maria Teresa de Borbón y Vallabriga, 1783
Oil on canvas, 130 × 116 cm. Washington D.C., National Gallery of Art

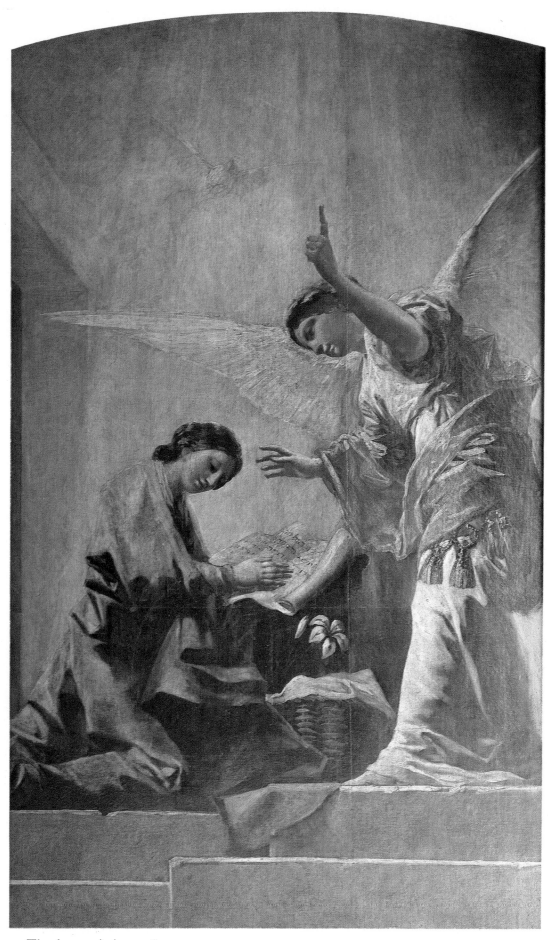

3. The Annunciation, 1785
 Oil on canvas, 280 × 177 cm. Spain, La Duquesa de Osuna y de Gandia

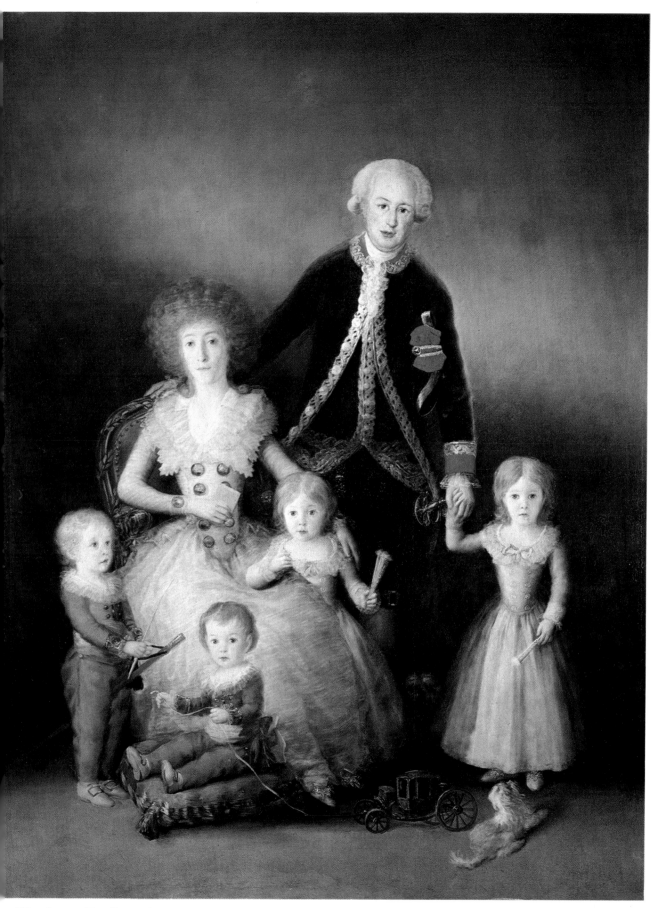

. The Osuna Family, 1788
Oil on canvas, 225 × 174 cm. Madrid, Museo del Prado

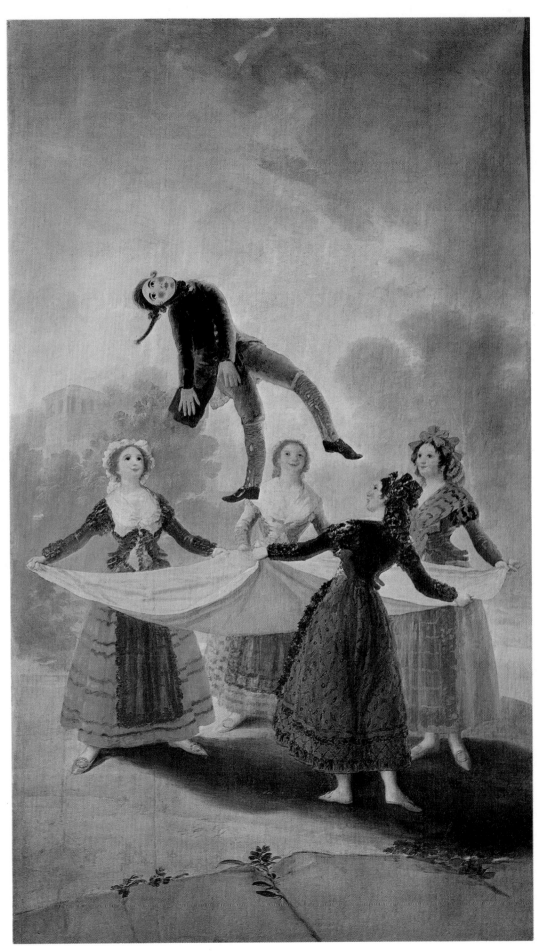

5. The Manikin ('El Pelele'), 1791–2
Oil on canvas, 267 × 160 cm. Madrid, Museo del Prado

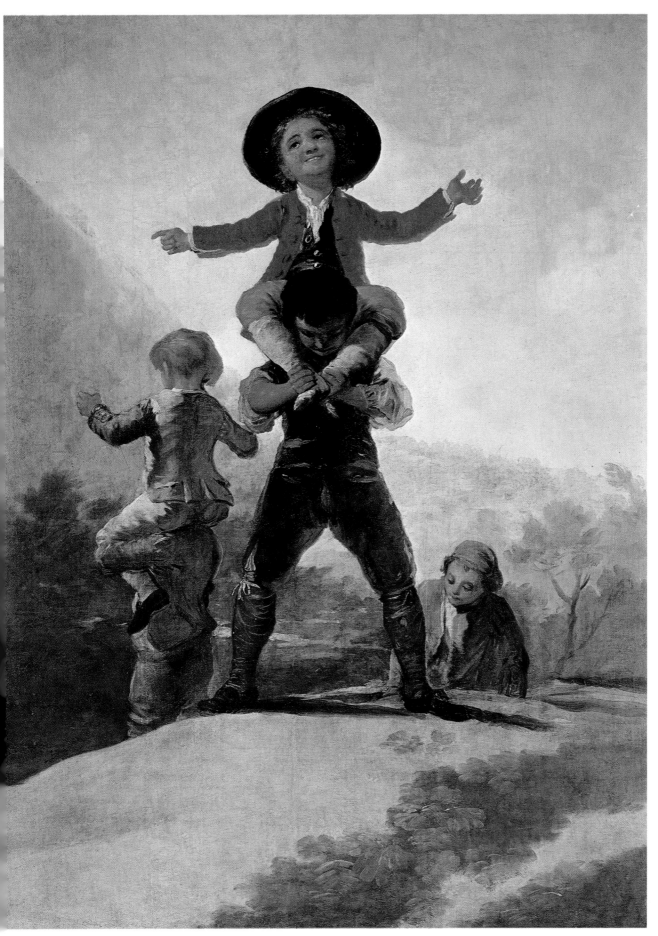

5. Pick-a-back ('Las Gigantillas'), 1791–2
Oil on canvas, 137 × 104 cm. Madrid, Museo del Prado

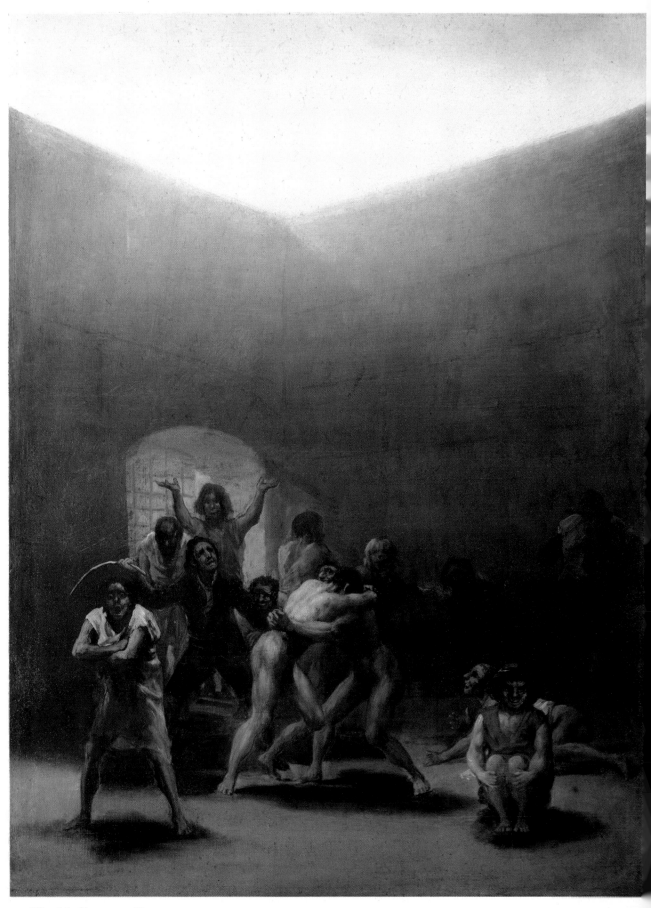

7. The Madhouse at Saragossa, 1793
Oil on metal panel, 43·8 × 32·7 cm. Dallas, Meadows Museum, Southern Methodist University

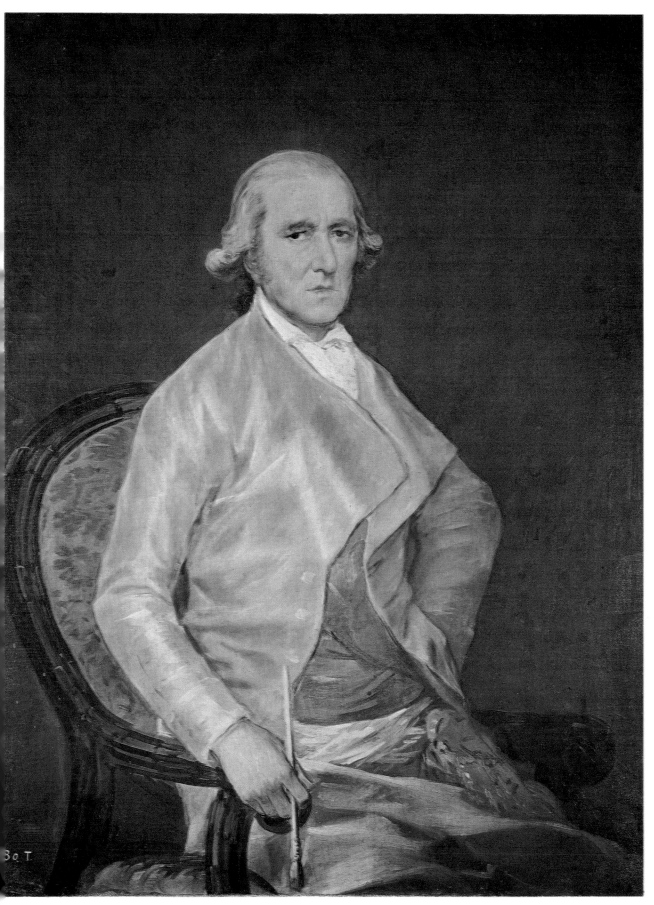

8. Francisco Bayeu y Subias, 1795
Oil on canvas, 112 × 84 cm. Madrid, Museo del Prado

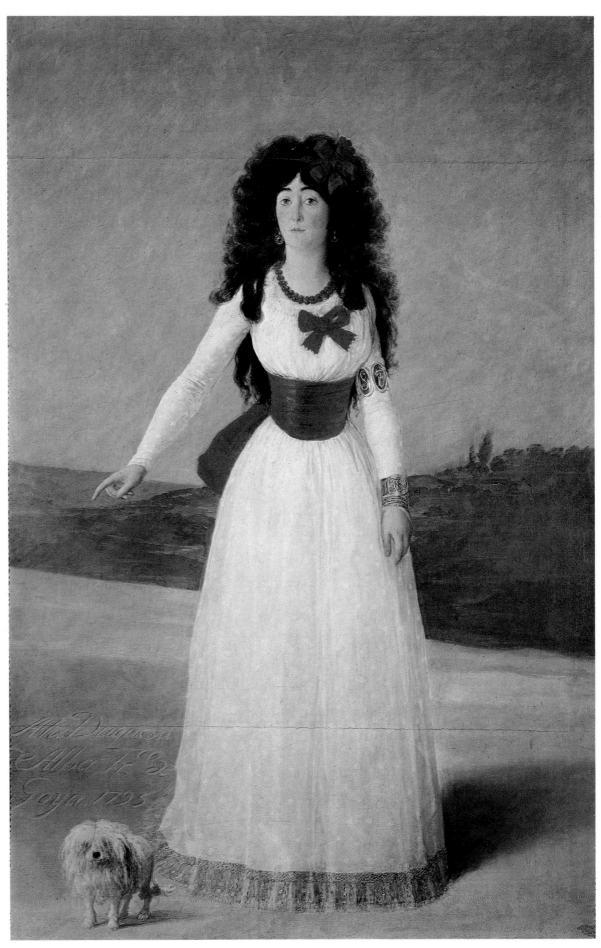

9. The Duchess of Alba, 1795
Oil on canvas, 194 × 130 cm. Madrid, El Duque de Alba

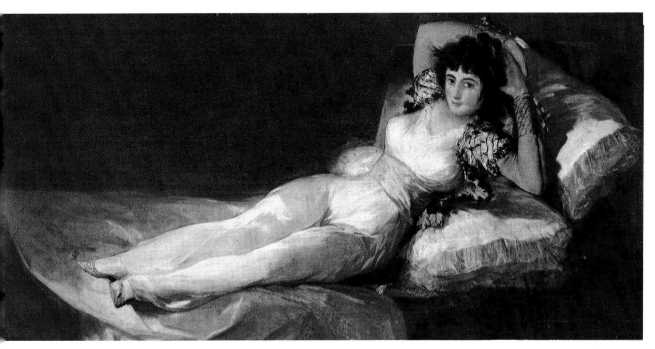

10. The Clothed Maja ('La Maja vestida'), *c.* 1805
Oil on canvas, 95 × 190 cm. Madrid, Museo del Prado

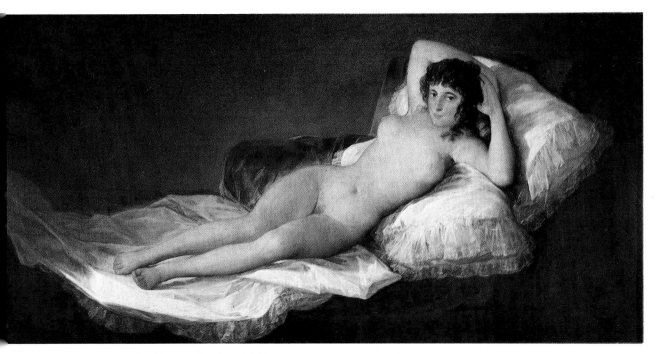

11. The Unclothed Maja ('La Maja desnuda'), *c.* 1805
Oil on canvas, 97 × 190 cm. Madrid, Museo del Prado

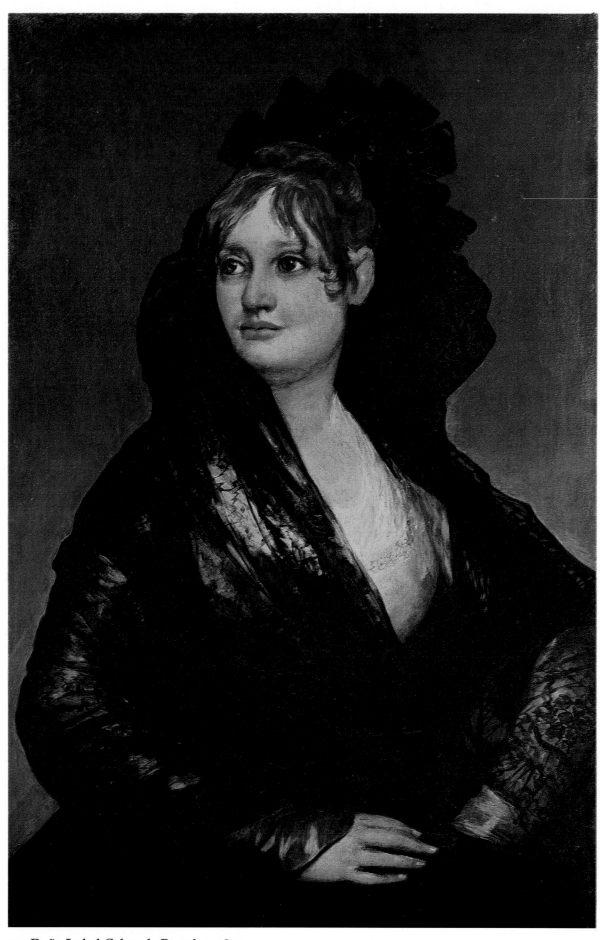

12. Doña Isabel Cobos de Porcel, *c.* 1805
 Oil on canvas, 82 × 54·6 cm. London, National Gallery

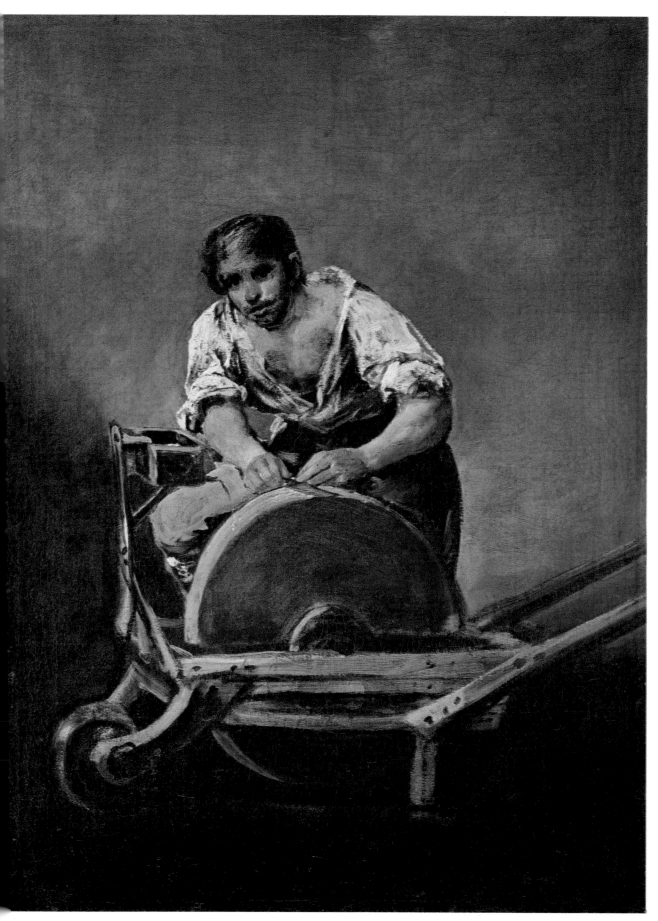

3. The Knife-grinder, *c.* 1810
Oil on canvas, 68 × 50 cm. Budapest, Szépmüvészeti Muzeum

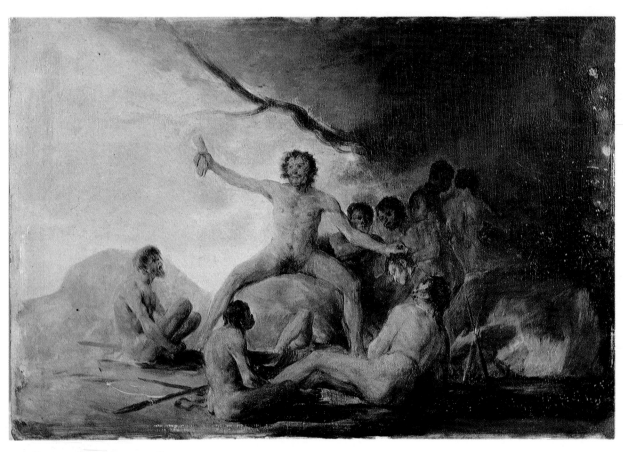

14. Scene of Savages, *c.* 1810
Oil on wooden panel, 31 × 50 cm. Besançon, Musée des Beaux-Arts

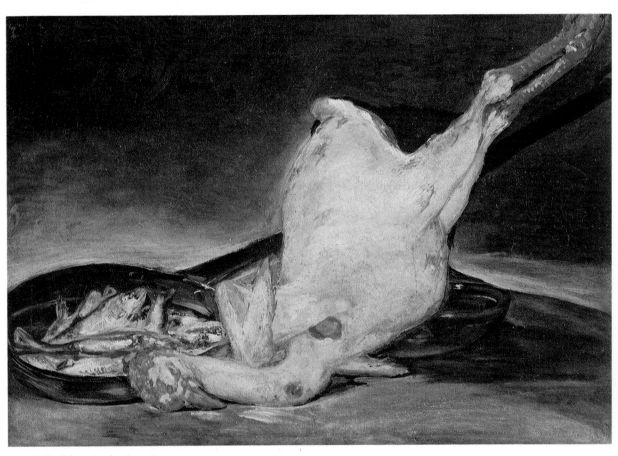

15. Still-life: plucked turkey, *c.* 1810
Oil on canvas, 44·8 × 62·4 cm. Munich, Alte Pinakothek

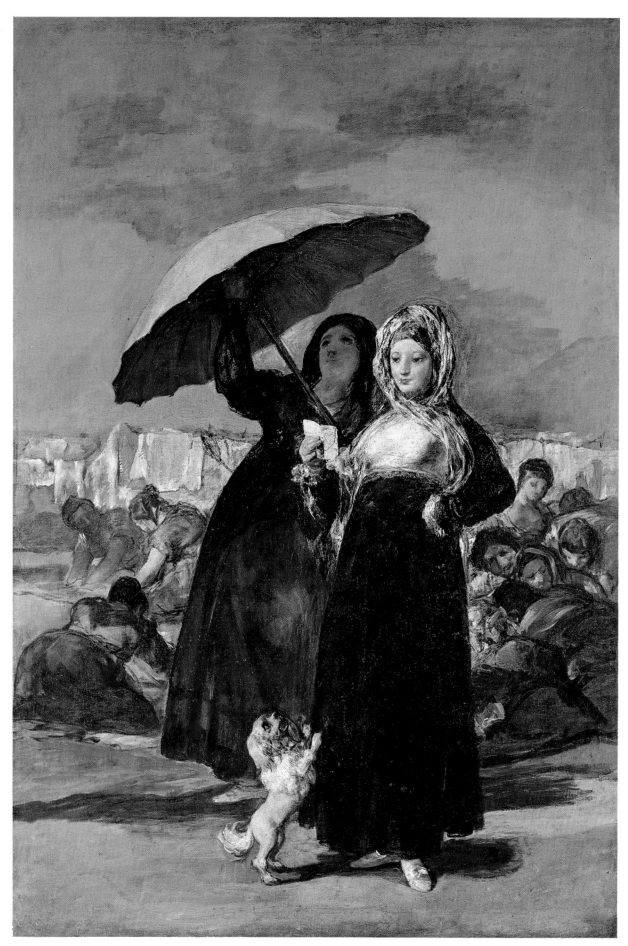

16. 'The Letter' ('La Carta'), *c.* 1812
Oil on canvas, 181 × 122 cm. Lille, Musée des Beaux-Arts

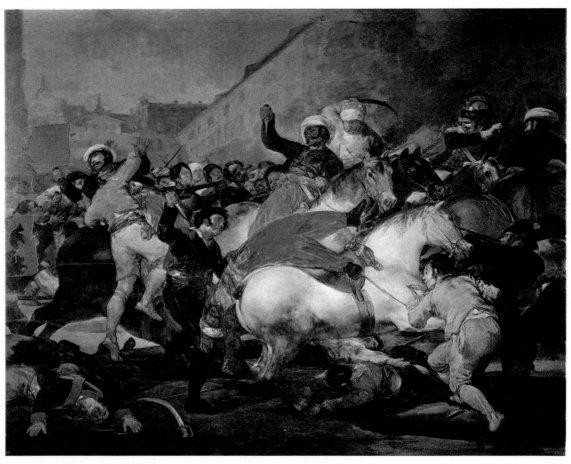

17. 'The 2nd of May' ('El 2 de Mayo'), 1814
Oil on canvas, 266 × 345 cm. Madrid, Museo del Prado

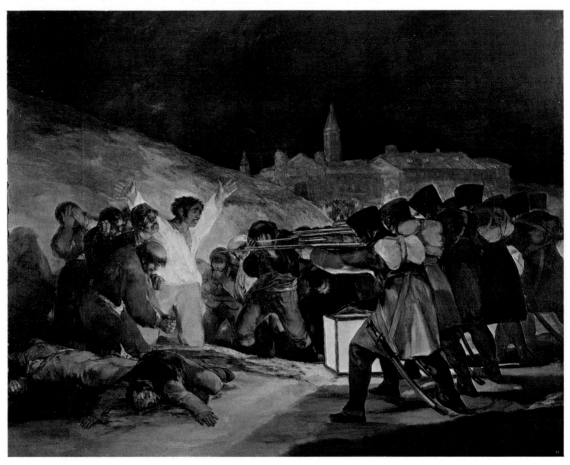

18. 'The 3rd of May' ('El 3 de Mayo'), 1814
Oil on canvas, 266 × 345 cm. Madrid, Museo del Prado

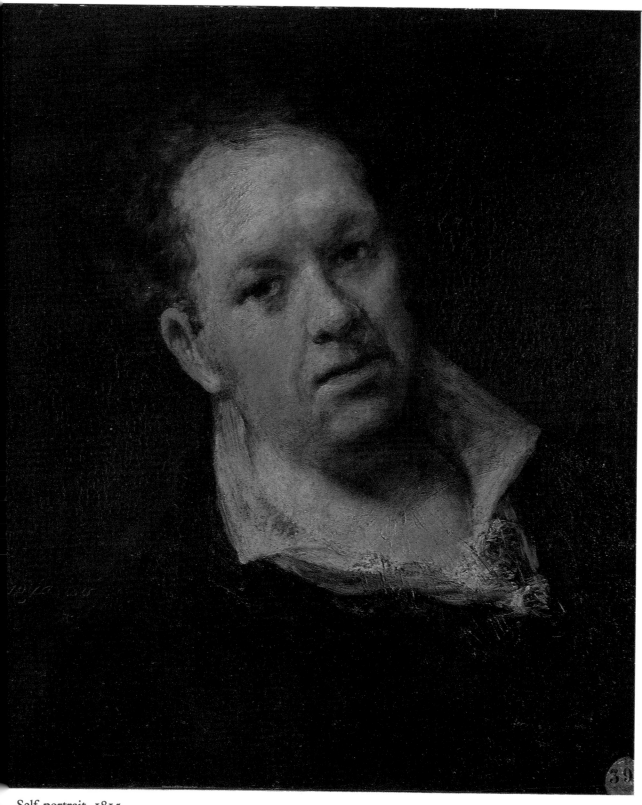

Self-portrait, 1815
Oil on wooden panel, 51 × 46 cm. Madrid, Real Academia de Bellas Artes de San Fernando

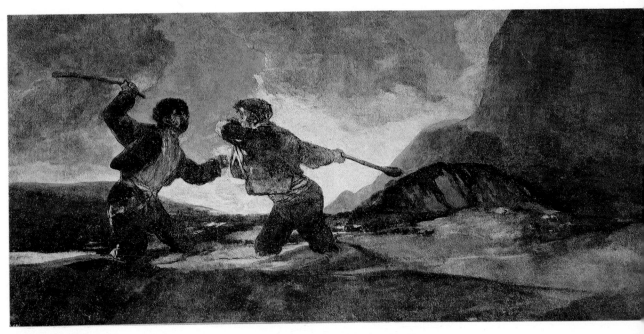

20. Duel with clubs, 1820–1
 Oil on canvas, 123 × 266 cm. Madrid, Museo del Prado

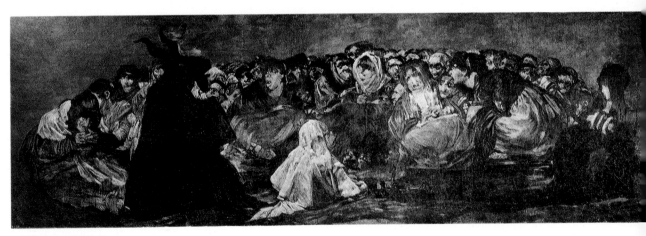

21. Witches' Sabbath, 1820–1
 Oil on canvas, 140 × 438 cm. Madrid, Museo del Prado

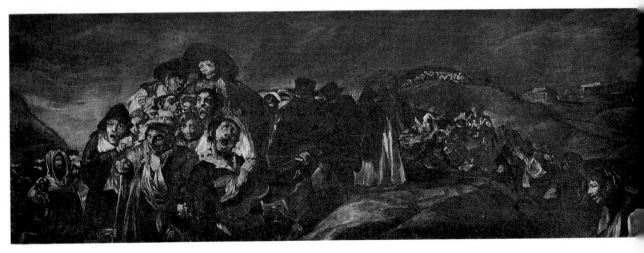

22. Pilgrimage of Saint Isidore, 1820–1
 Oil on canvas, 140 × 438 cm. Madrid, Museo del Prado

Drawings

The seven hundred or so extant drawings by Goya, which probably represent only a fraction of his enormous output, fall into two categories. To the first belong those made as preparatory to paintings and engravings, of which the former employ a whole variety of techniques, and range in type from the study of some detail or the rapid note of some pictorial idea to the more finished compositional study. They belong to all periods of his career, but understandably decrease in frequency as his need to make preparatory studies decreased. The bulk of these drawings are lost. A large proportion of the careful preparatory drawings made by Goya for his engravings are, however, preserved. To the second category belong the drawings he made as independent works of art in their own right. The majority of these appear to have been made in numbered series, and it is clear from the gaps in the numeration that many of these drawings are also lost to us. They take a very special place in his *œuvre*, and it is upon them that Goya's reputation as one of the great original geniuses of drawing depends. With few exceptions they were made during the two periods in his career when he was working more especially on his own painting and needed to set down the images that teemed in his mind. The first period was during the few years of convalescence after his serious illness of 1792–3, and the second embraces the twenty years from the outbreak of war in 1808 to his death in 1828. During both Goya was occupied comparatively little on official works and was able to devote himself to his own work. His activity as an engraver also effectively belongs to the same two periods.

Some of Goya's earliest drawings are those he made in connection with his tapestry cartoons. Like his paintings of the time they show the young artist's acquaintance with the art of his time. The spirited chalk drawings of the *Majo smoking* (No 23) and *Majo clapping his hands* (No 24) (in time to the music), studies for details in the *Picnic* and *Dance on the Banks of the Manzanares*, of 1776 and 1777 respectively (the first two tapestry cartoons he made representing contemporary pastimes and costumes), have the lightness and liveliness of Rococo art and witness the artist's first introduction to what was to be his lifelong concern: the study of the character and behaviour of the people around him. The splendid red-chalk drawing of the *Duke of Wellington* (No 33), made in 1812, which formed the basis of the various portraits Goya made of the Duke (including those in the National Gallery and the Wellington Museum, London),

has something of the strength and richness of his paintings of the time.

The first time Goya really turned to making drawings for their own sake was during his stay on the Duchess of Alba's estate in Sanlúcar de Barrameda, in Andalucia, from late 1796 to 1797, when he produced a whole series of drawings recording the everyday activity and events on the estate (Nos 25–28). Whilst these lively drawings were based on his first-hand observations, they are certainly not direct records and may be seen as his first important essays in working out the expressive possibilities of the technique. They are carried out in the free and 'painterly' technique of brush and wash. A number of them were developed further in his engraved series of the '*Caprichos*' (Nos 44–50), his first great exercise in imaginative design.

The large majority of Goya's independent drawings, however, were made during the last twenty years of his life, and they include some of the most powerful and original masterpieces of drawing of all time. In them, Goya's imaginative powers appear to have no limits. They are executed in two techniques, both particularly suited to Goya's free and spontaneous approach: that of brush and wash, as before but now employed with a greater freedom and strength, and that of black chalk. The depth of tone and richness of effect that Goya derives from his use of the brush or chalk is perhaps unparalleled. To the war years are probably to be dated such drawings as the *Three men digging* (No 31), closely related to his painting of *The Forge* and related in spirit to plates 2 and 3 of his engraved series of the '*Disasters*' (Nos 51 & 52), and the *Water-carrier* (No 30), which may similarly be related to a painting he made of the same subject, a pendant to the painting of *The Knife-grinder* (No 13).

More appropriate in their observations to the post-war years, to which they probably belong, are the drawings dealing with prisoners, such as '*For being of generous spirit*' (No 36); the series of nightmare scenes; and the series of madmen, executed in a technique of incredible vigour and richness ('*Raving madman*' (No 40)). The appeal of such drawings as, say, *Man, woman, child and dog walking in a landscape* (No 32) depends both on the beauty of the technique and the sympathetic treatment of the human theme.

In France we see the aged artist recording the novel things he saw in his new environment, '*New carriages or shoulder-chairs*' (No 42).

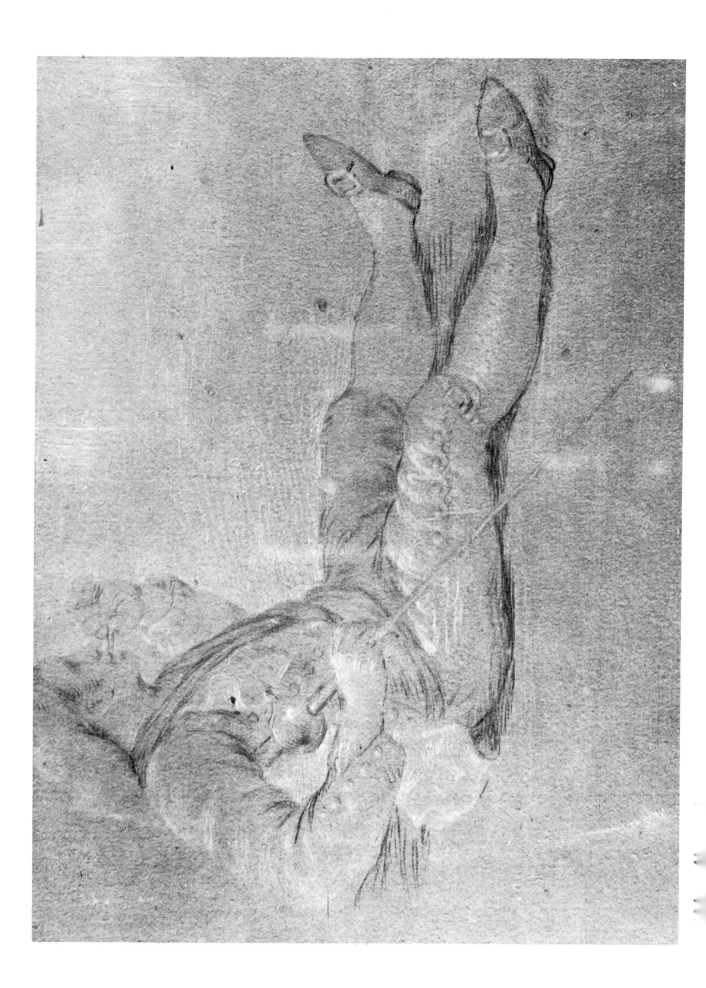

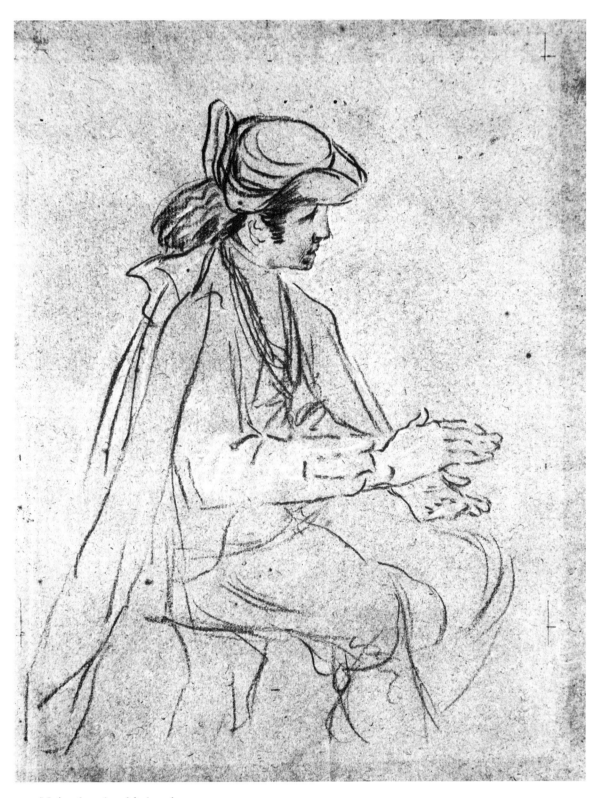

24. Majo clapping his hands, 1777
Chalk on toned paper, 203 × 152 mm. Madrid, Museo del Prado

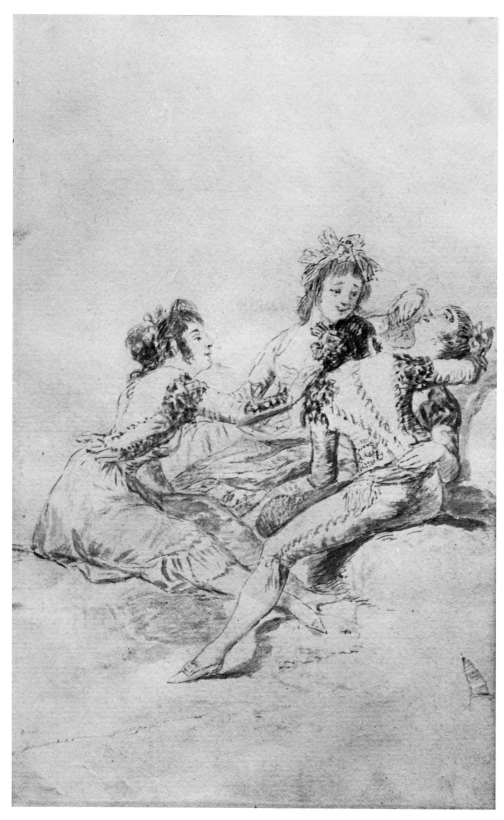

25. Maja fainting ('The Swoon'), 1796–7
Brush and wash, 220 × 130 mm. Madrid, Museo del Prado

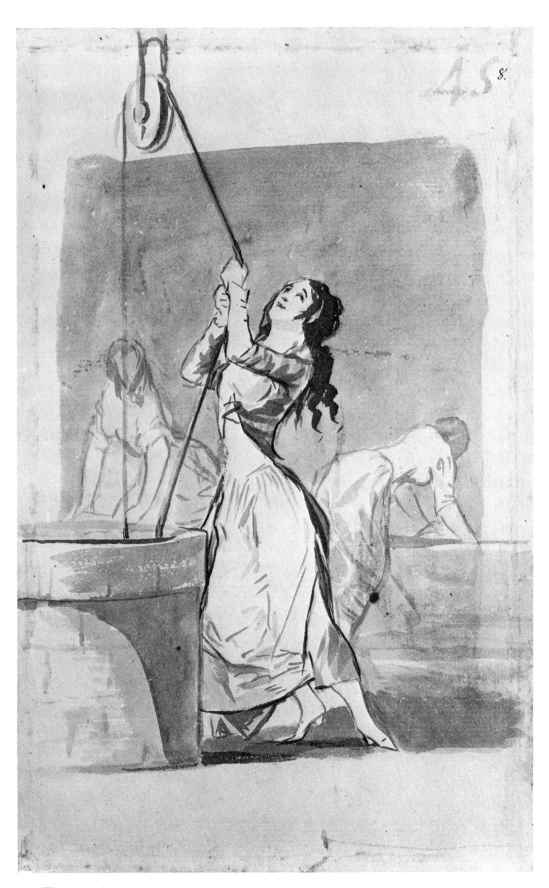

26. Three washerwomen, 1796–7
Brush and wash, 235 × 145 mm. Madrid, Museo del Prado

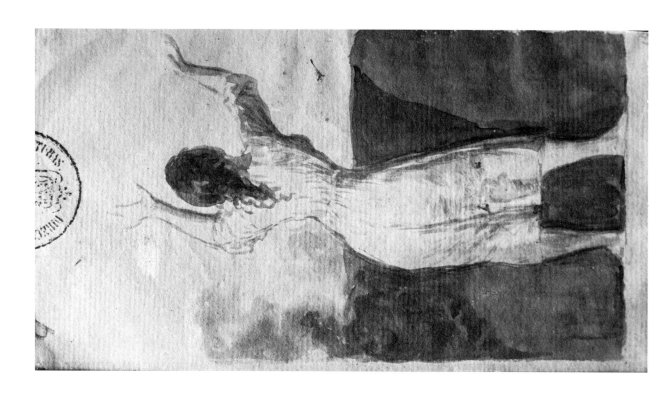

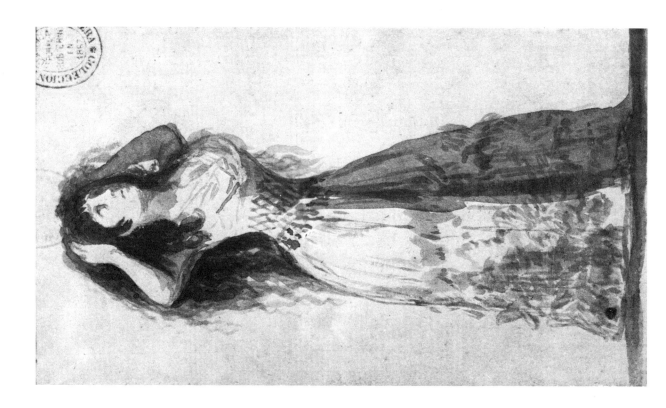

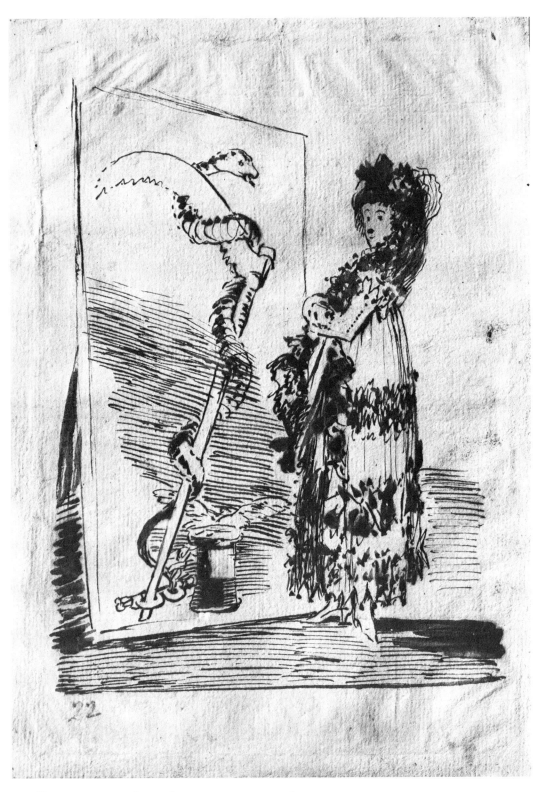

29. Young woman mirrored as a serpent, *c.* 1796–7
Pen, 200 × 140 mm. Madrid, Museo del Prado

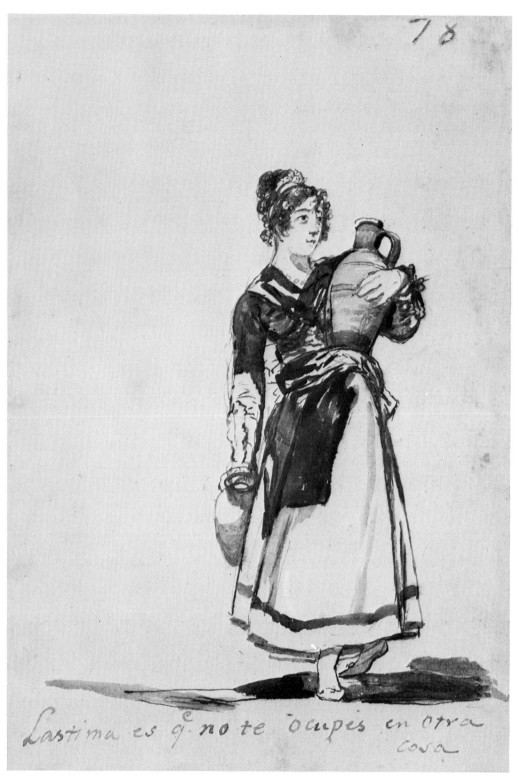

Lastima es q.^e no te ocupes en otra cosa

30. The Water-carrier, *c.* 1810
Brush and wash, 203 × 127 mm. (Owner unknown)

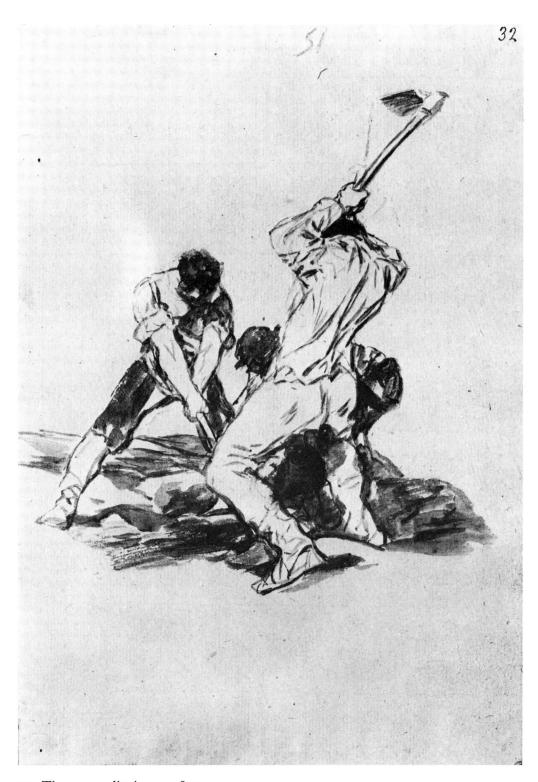

31. Three men digging, c. 1810
Brush and wash, 207 × 143 mm. New York, Metropolitan Museum of Art (Dick Fund, 1935)

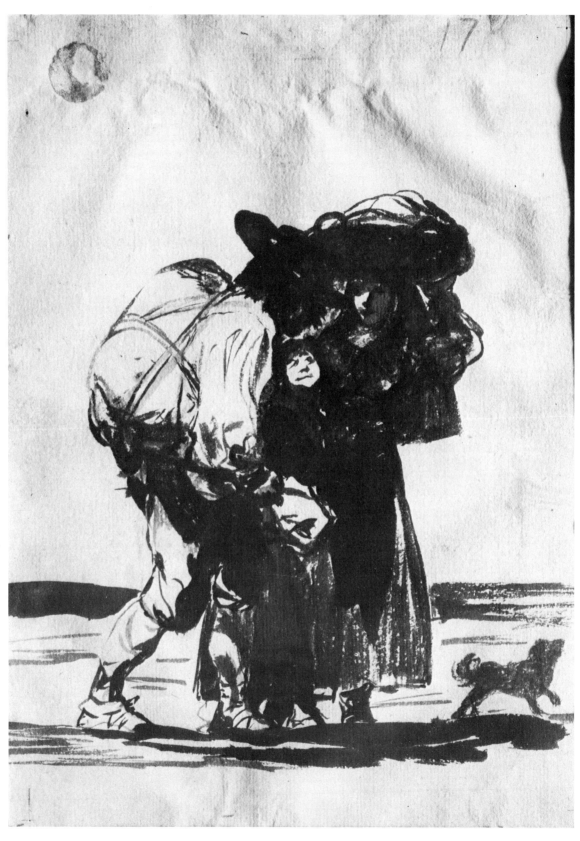

32. Man, woman, child and dog walking in a landscape, c. 1812
Brush and wash, 215 × 155 mm. Madrid, Museo del Prado

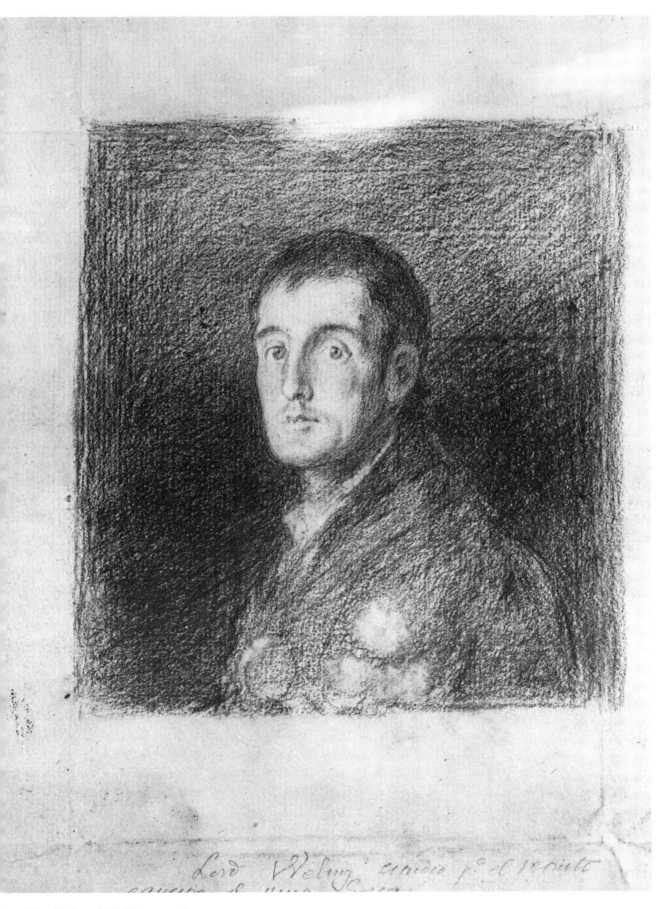

33. The Duke of Wellington, 1812
Red chalk, 232 × 175 mm. London, British Museum

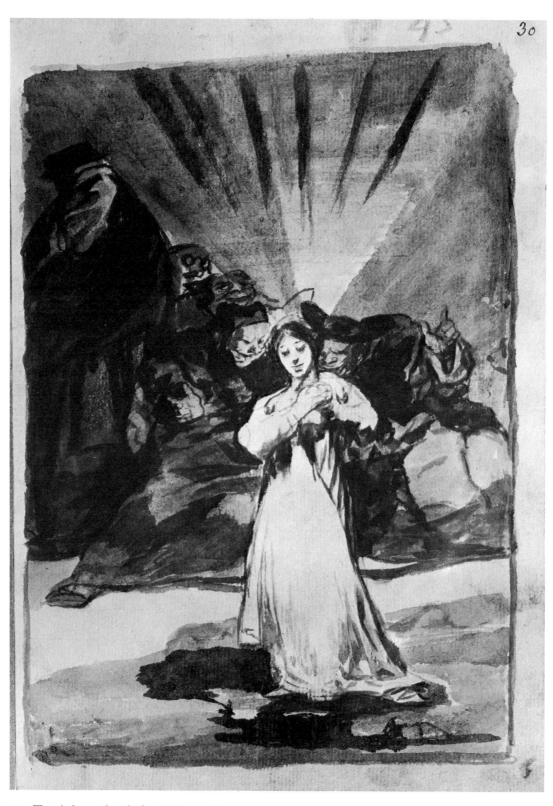

34. Truth beset by dark spirits, *c.* 1815
Brush and wash, 205 × 143 mm. New York, Metropolitan Museum of Art (Dick Fund, 1935)

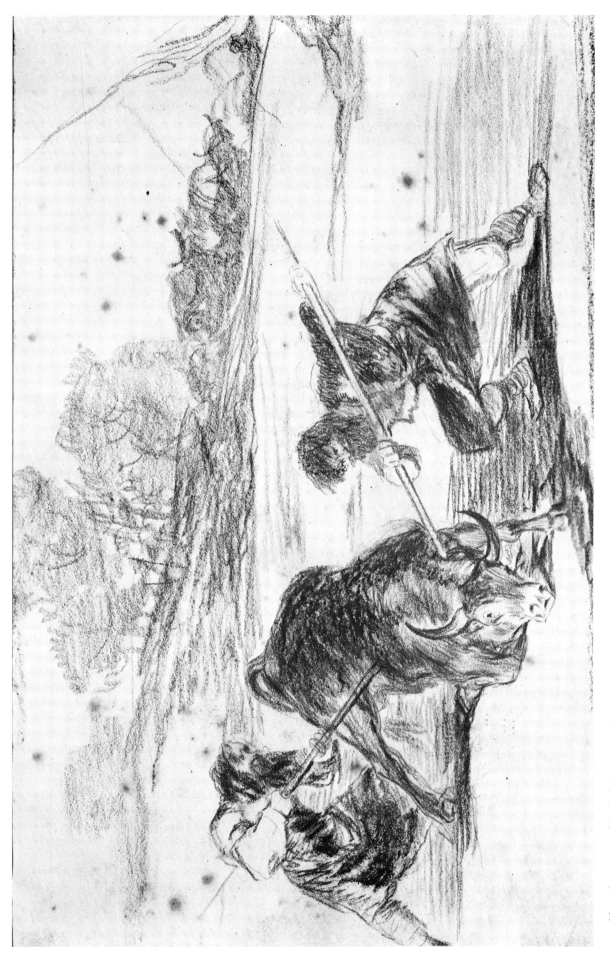

35. 'Another way of bull-fighting on foot' (Study for Plate 2 of the 'Tauromaquia'), 1815
Red chalk, 181 × 292 mm. Private collection

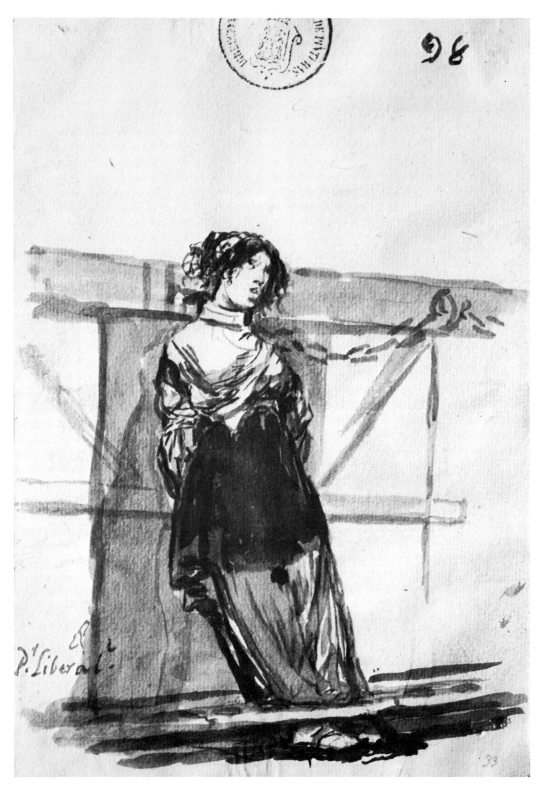

36. 'For being of generous spirit' ('Por Liberal'), *c.* 1815
Brush and wash, 220 × 140 mm. Madrid, Museo del Prado

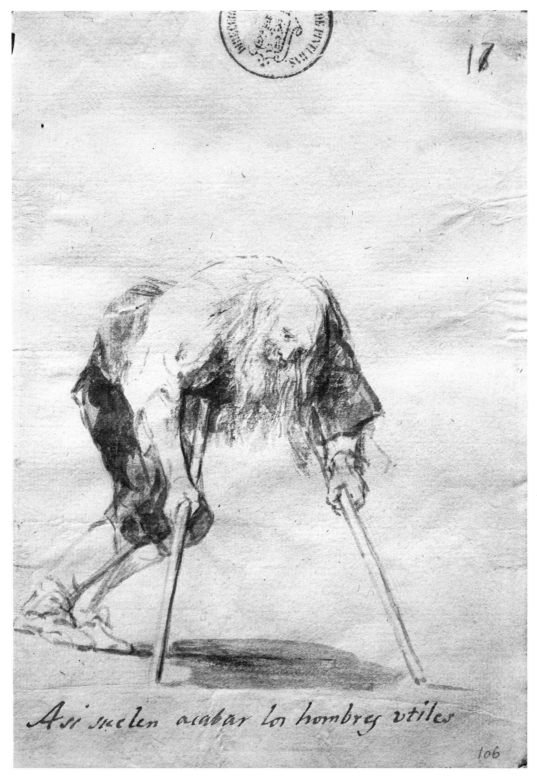

37. 'Thus the useful end their days' ('Asi suelen acabar los hombres utiles'), *c.* 1815
Brush and wash, 200 × 140 mm. Madrid, Museo del Prado

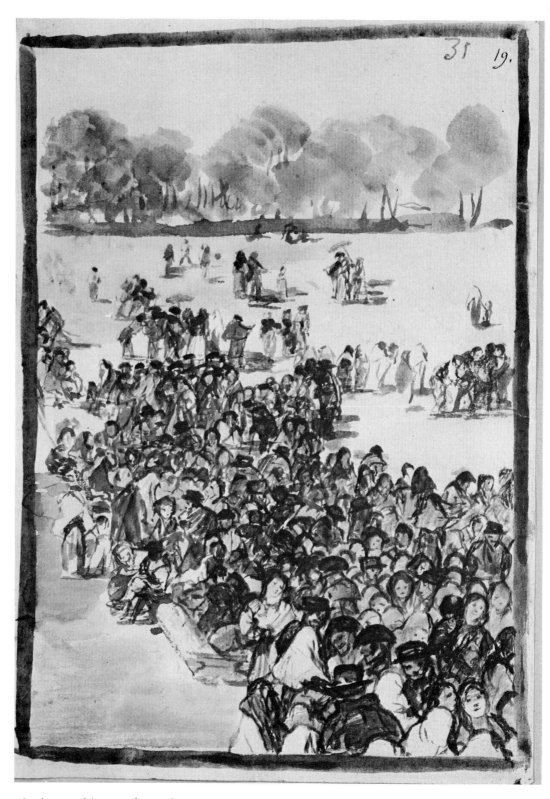

38. A crowd in a park, *c.* 1815
Brush and wash, 205 × 145 mm. New York, Metropolitan Museum of Art

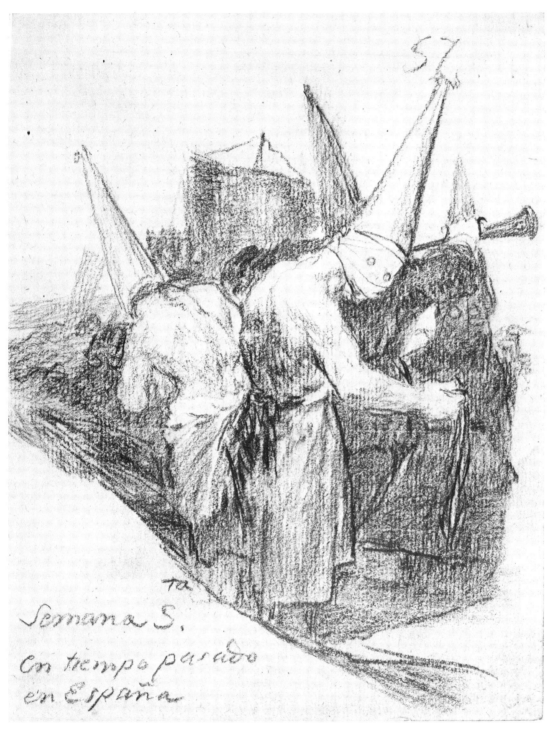

39. 'Holy Week in Spain in former times' ('Semana Sta en tiempo pasado en España'), *c.* 1815
Black chalk, 191 × 146 mm. Ottawa, National Gallery of Canada

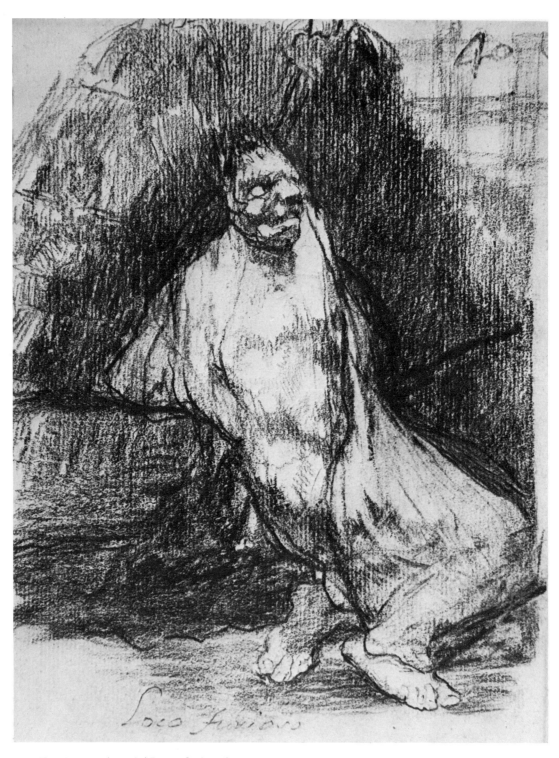

40. 'Raving madman' ('Loco furioso'), *c.* 1818
Black chalk, 190 × 145 mm. Private collection

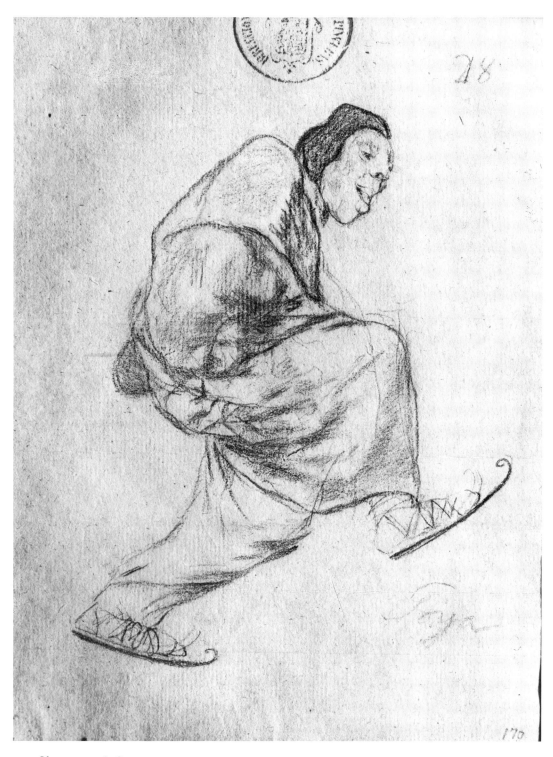

41. Skater, *c.* 1818–20
 Black chalk, 191 × 146 mm. Madrid, Museo del Prado

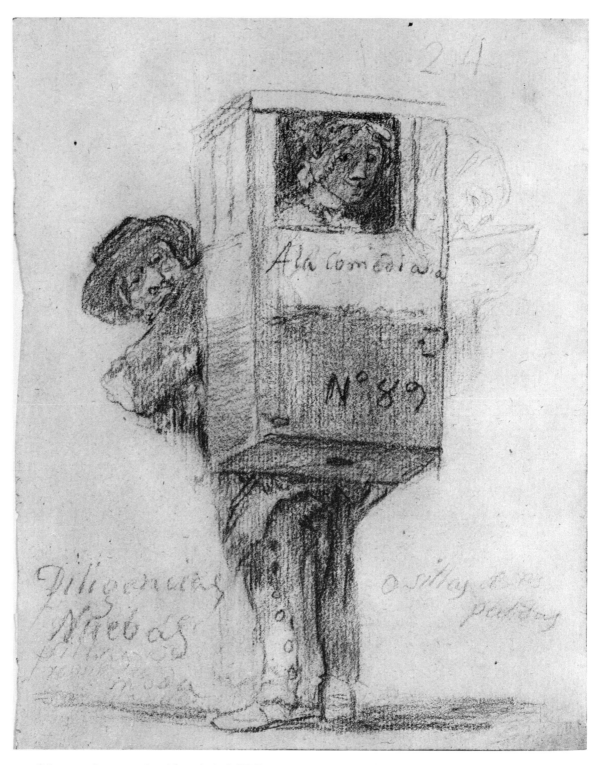

42. 'New carriages or shoulder chairs' ('Dilgencias Nuebas o sillas de espaldas') *c.* 1824–5
Black chalk, 191 × 152 mm. Boston, Museum of Fine Arts (Arthur Tracy Cabot Fund)

Prints

About three hundred of Goya's engraved plates are preserved, and they include almost the whole of his mature work in this field. By far the greater number are accounted for by the various series, and almost all are in the technique of etching and aquatint, one of a number of techniques invented or perfected in the eighteenth century for the purpose more especially of reproducing paintings. Goya, however, employed it as an artistic technique in its own right. Late in his career he was to be one of the first great artists to take up the new technique of lithography.

We do not know when Goya was first introduced to engraving, but his undated *Flight into Egypt* has all the appearance of the work of a young artist new to the technique. The etching of the *Garrotted Man*, possibly to be dated in the late 1770s, shows an acquaintance with Tiepolo's etchings, although the subject is his own and is remarkable for the time. The series of sixteen plates recording Velazquez's paintings (No 43), some executed with the etching needle alone and others combining etching with aquatint, may be seen more especially as an exercise in the new technique.

Goya's first independent engravings, the remarkable satirical series of the '*Caprichos*' (Caprices) (Nos 44–50), were produced in 1797. Like the subsequent series he was to make they were intended partly as a commercial enterprise. He could have hoped the subject-matter might be of topical interest, but the designs were too new for the series to have a popular appeal, and the engravings were soon withdrawn from sale. In 1803 Goya handed over the engraved plates and the unsold engravings to the royal printing house in exchange for a pension for his son, Xavier. Produced towards the end of his few years of convalescence, just before he was ready to return to his official work, they may be seen as an extensive exercise in imaginative design, and as the culmination of his activity during his first years of artistic freedom. Whilst his engravings were based on carefully worked-out drawings, they can in no way be regarded as reproductions of the drawings. In working on the engravings he was able to give a finality to the designs, interpreting them entirely in terms of the new technique. In these works in black-and-white, Goya concentrated more especially on the design or image. The extent of the variety of these images and of his handling of the etched line and the aquatint ground, which is an integral part of the image, can only be appreciated by perusing the whole series of eighty plates. Their inventiveness and expressive power is immense, and for their technique alone the plates are perhaps unsurpassed except by Goya's own later engravings. What is possibly the most remarkable new feature of these images is their ability, as it were, to embody an emotion, something hardly attempted again for another hundred years, in the work, say, of Odilon Redon. If we consider the beautiful design of '*The bogey-man is coming*' (No 45), we may see that what it expresses depends on an entirely new conception of design and drawing. The whole design is concentrated on the children who seek refuge in their mother's breast as they hear the 'harmless' words that it is almost the part of every mother to repeat; and the remarkable treatment of this area of the design seems to express the moment that the real and irrational fear enters the children's being. This is social satire of a special kind.

The war, a tragic social reality distinct from the social injustices and disquiet of the 1780s and 1790s, prompted Goya to turn again to engraving. He probably started on his second great masterpiece of etching and aquatint, the '*Disasters of War*' (Nos 51–61), in 1810, in which year he dated a number of the plates. He may well have hoped that circumstances after the war might make it possible to publish the series of eighty plates, but this was not to be. The designs are even more varied, richer in treatment and more compelling than those of the '*Caprichos*', and display a human sympathy and pathos of a dimension hardly called for in the earlier series. The whole of the war is recounted, from the grand initial designs of the '*With or without cause*' and '*The same*' (Nos 51 & 52), through the scenes of execution, '*There is nothing one can do*' (No 53), mutilations, '*Why?*' (No 56), and famine (the irresistible design of the '*Poor mother!*' (No 59), which draws the child unwittingly along after its mother), to scenes of the aftermath of the war, '*They do not know the road*' (No 61), a remarkable interpretation of the theme of the' blind leading the blind'. To achieve the powerful effect of these designs Goya stretched the technique of etching and aquatint to its limits, introducing, when the etching needle and the aquatint ground was not sufficient, the burnisher and roulette proper to the mezzotint technique, the burin of the line-engraver, or the drypoint needle. The freedom of his handling of his medium is comparable to that of his paintings.

In 1815 Goya produced his series of thirty-three plates of the *Tauromaquia* (No 63), illustrating the history of the bull-fight, in the same technique of etching and aquatint. It was published in the following year but with no success. The '*Disparates*' (Follies), or '*Proverbios*' (Nos 65 & 66), on which Goya was probably working towards the end of the 1810s, take the technique of etching and aquatint even further than did the '*Disasters*'. The tragic events and atmosphere of the post-war years, which in part inspire the designs, were something less tangible, and in some ways more terrifying, than the events of the war. In many of the plates Goya refers back to themes he had treated before in his paintings and engravings (compare *Feminine Folly* (No 65) with *The Manikin* (No 5)) thereby making their meaning more explicit.

Goya continued to employ the etching and aquatint technique for individual plates but for his latest engravings he turned also to the recently discovered technique of lithography. His earliest known essay in the lithographic process is the *Woman spinning*, dated in 1819, only a year or two after the process was introduced to Madrid; and in 1824, in Bordeaux, he produced the first and one of the greatest masterpieces in the lithographic technique, the series of the '*Bulls of Bordeaux*' (No 70).

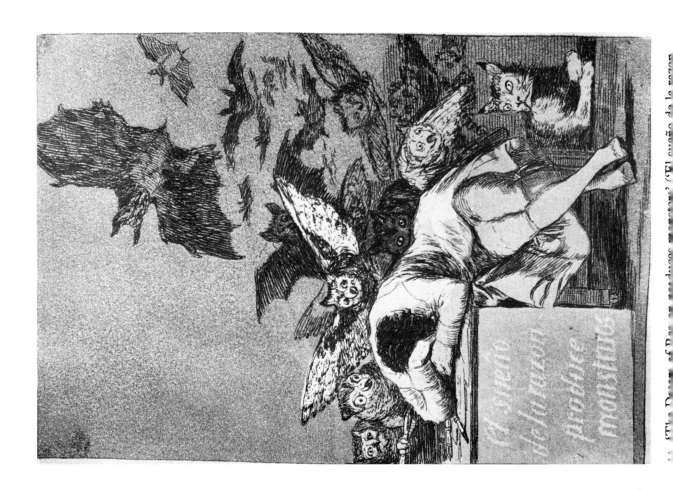

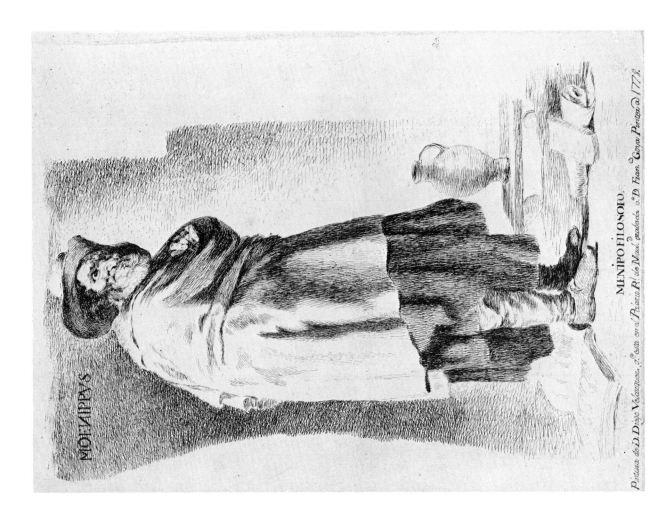

11. 'The Dream of Reason produces monsters.' ('El sueño de la razon
produce monstruos.')

46. Capricho 16. 'May God forgive her: and it was her mother!'
('Dios la perdone: Y era su madre'), 1797
Etching and aquatint, 200 × 150 mm. London, Tomás Harris Coll.

45. Capricho 3. 'The bogey-man is coming' ('Que viene el Coco'), 1797
Etching and aquatint, 215 × 150 mm. London, Tomás Harris Coll.

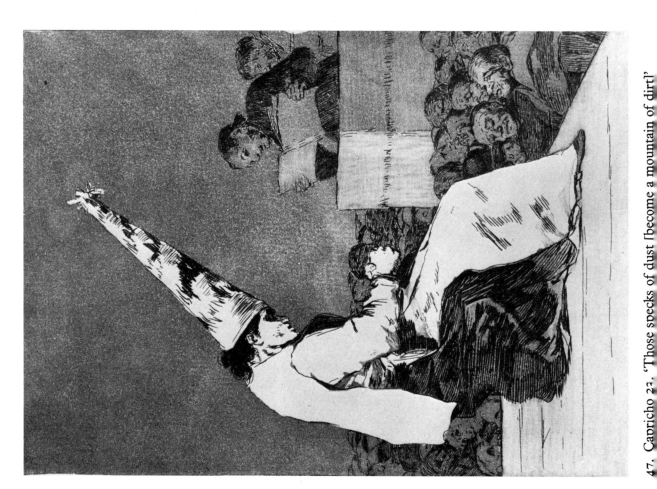

48. Capricho 25, 'He broke the jug!' ('Si quebró el Cantaro'), 1797

47. Capricho 23, 'Those specks of dust [become a mountain of dirt]'

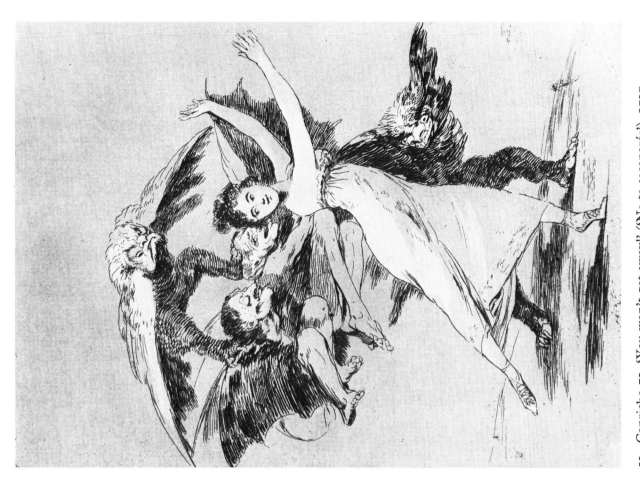

50. Capricho 72. 'You won't get away!' ('No te escaparás'), 1797
Etching and aquatint, 215 × 150 mm. London, Tomás Harris Coll.

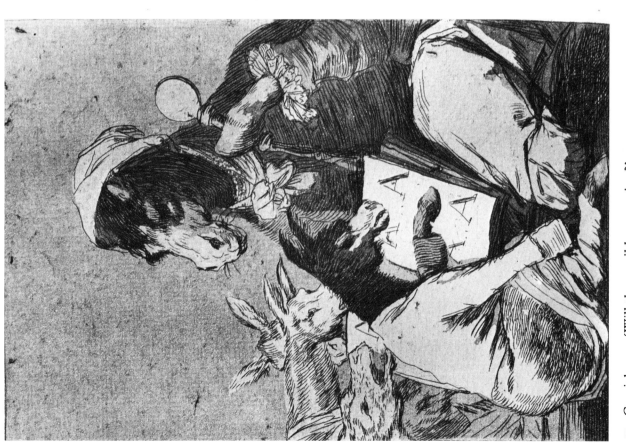

49. Capricho 37. 'Will the pupil be any wiser?'
('Si sabrá mas el discipulo?'), 1797
Etching and aquatint, 215 × 150 mm. London, Tomás Harris Coll.

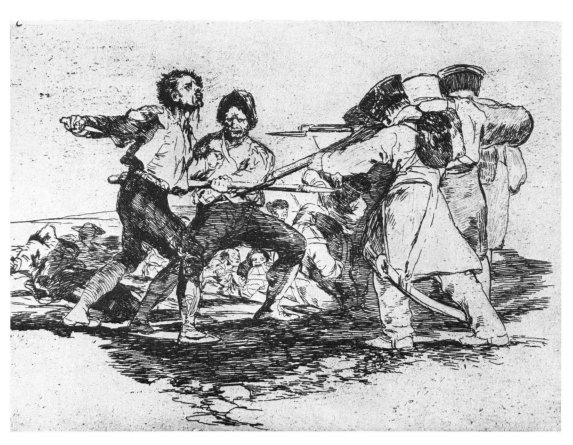

51. Disaster 2. 'With or without cause' ('Con razon ó sin ella'), *c.* 1810
 Etching with other techniques, 155 × 205 mm. London, Tomás Harris Coll.

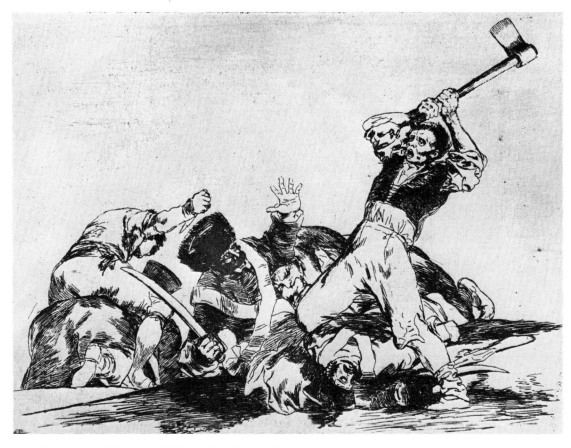

52. Disaster 3. 'The same' ('Lo mismo'), *c.* 1810
 Etching with other techniques, 160 × 220 mm. London, Tomás Harris Coll.

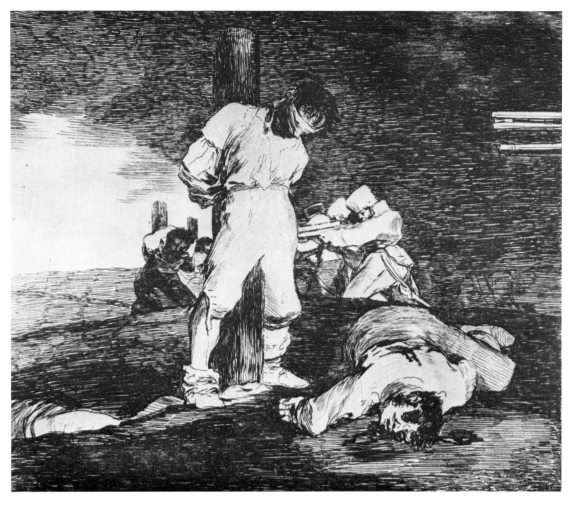

53. Disaster 15. 'There is nothing one can do' ('y no hai remedio'), *c.* 1810
Etching with other techniques, 145 × 165 mm. London, Tomás Harris Coll.

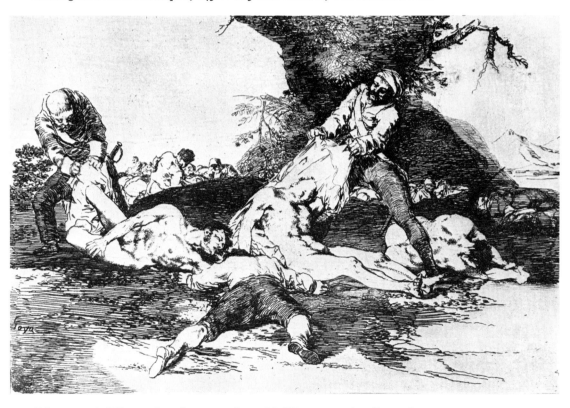

54. Disaster 16. 'They take advantage from it' ('Se aprovechan'), *c.* 1810–11
Etching with other techniques, 160 × 235 mm. London, Tomás Harris Coll.

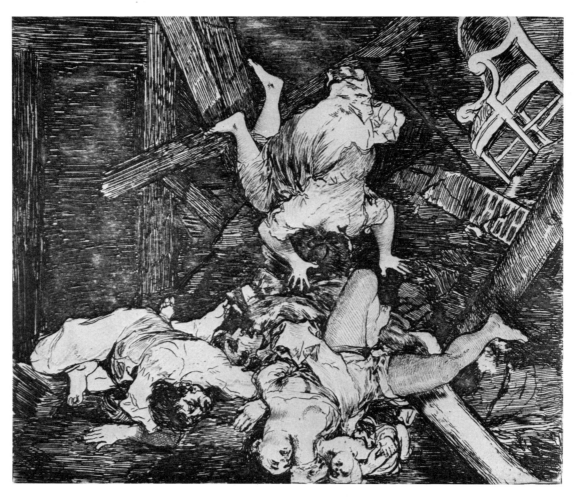

55. Disaster 30. 'Ravages of war' ('Estragos de la guerra'), *c.* 1810–12
Etching with other techniques, 140 × 170 mm. London, Tomás Harris Coll.

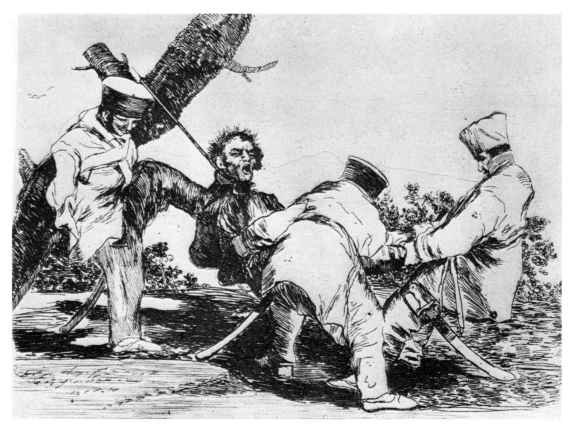

56. Disaster 32. 'Why?' ('¿Por qué?'), *c.* 1810–12
Etching with other techniques, 155 × 205 mm. London, Tomás Harris Coll.

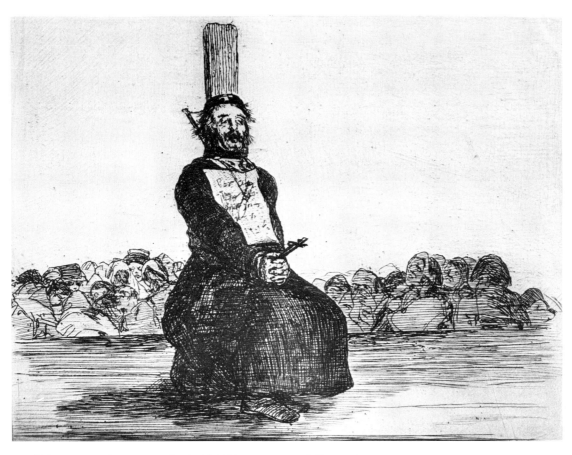

57. Disaster 34. 'Because of a knife' ('Por una navaja'), *c.* 1810–12
Etching with other techniques, 155 × 205 mm. London, Tomás Harris Coll.

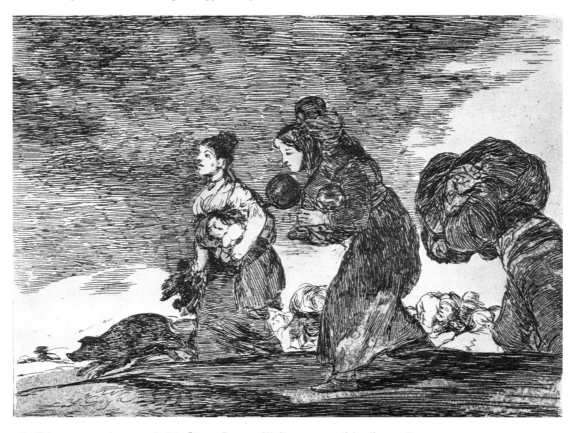

58. Disaster 45. '. . . and this [I saw] as well' ('y esto tambien'), *c.* 1810–12
Etching with other techniques, 165 × 220 mm. London, Tomás Harris Coll.

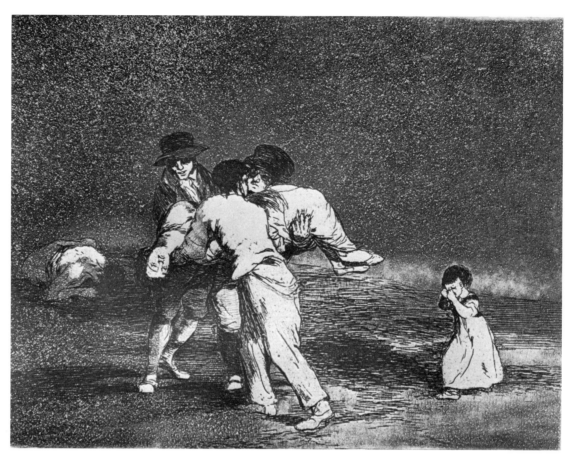

59. Disaster 50. 'Poor mother!' ('Madre infeliz'), c. 1811–12
Etching with other techniques, 155 × 205 mm. London, Tomás Harris Coll.

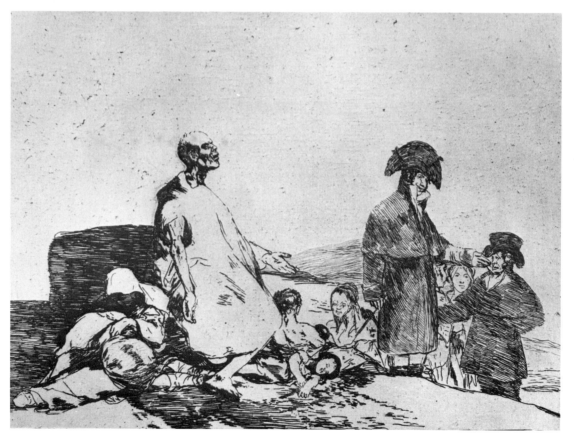

60. Disaster 61. 'Are they of another race?' ('Si son de otro linaje'), c. 1811–12
Etching with other techniques, 155 × 205 mm. London, Tomás Harris Coll.

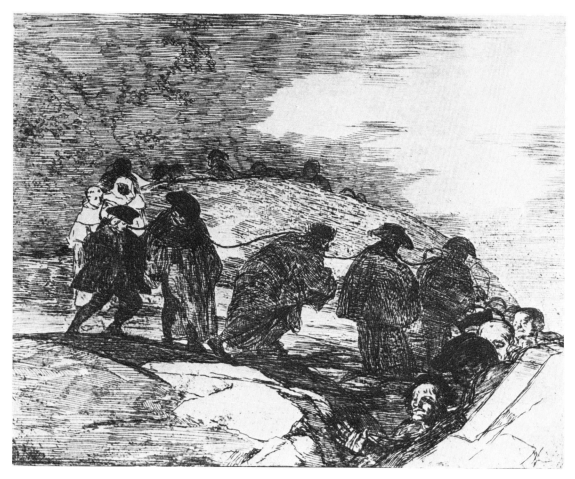

61. Disaster 70. 'They do not know the road' ('No saben el camino'), *c*. 1812–14
Etching with other techniques, 175 × 220 mm. London, Tomás Harris Coll.

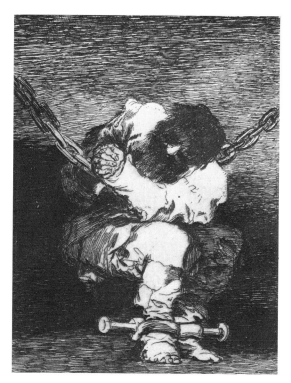

62. 'The detention as barbarous as the crime'
('Tan bárbara la seguridad como el delito'), *c*. 1815
Etching, 110 × 85 mm. London, British Museum

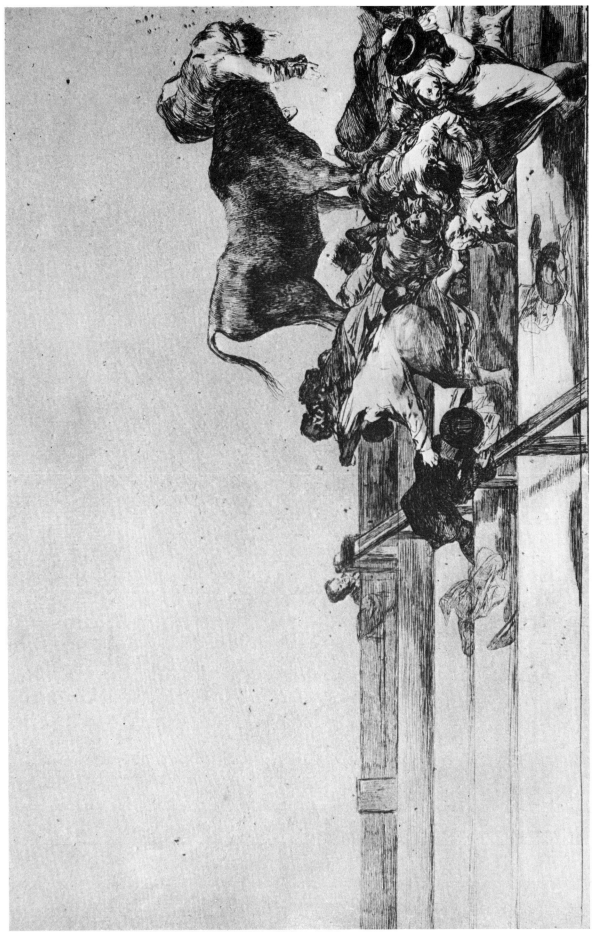

62 Tauromaquia 21 'The terrible events in the stands at Madrid . . .'

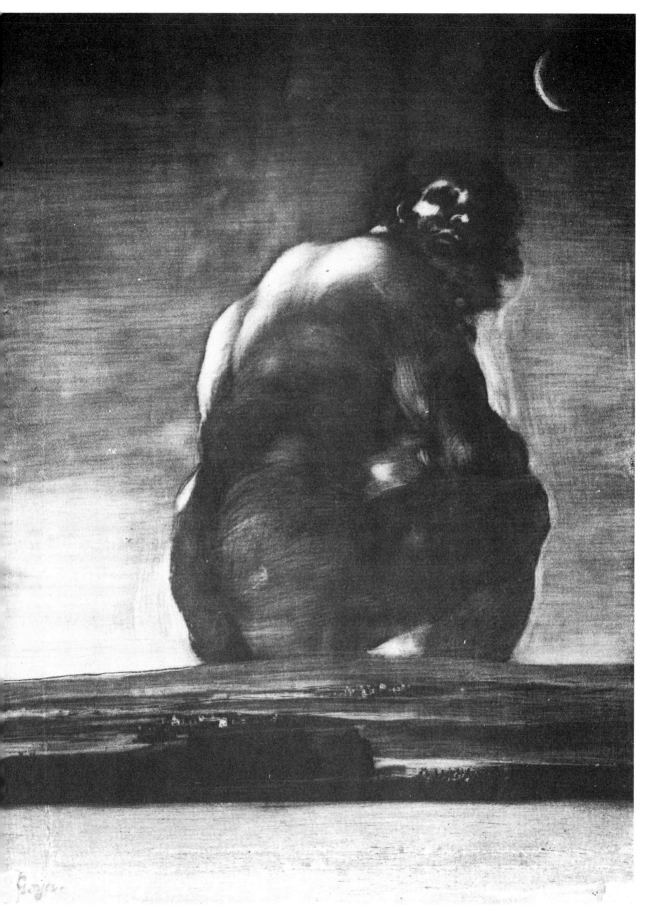

4. The Colossus, *c.* 1815–18
Mezzotint, 285 × 210 mm. Berlin, Kupferstichkabinett

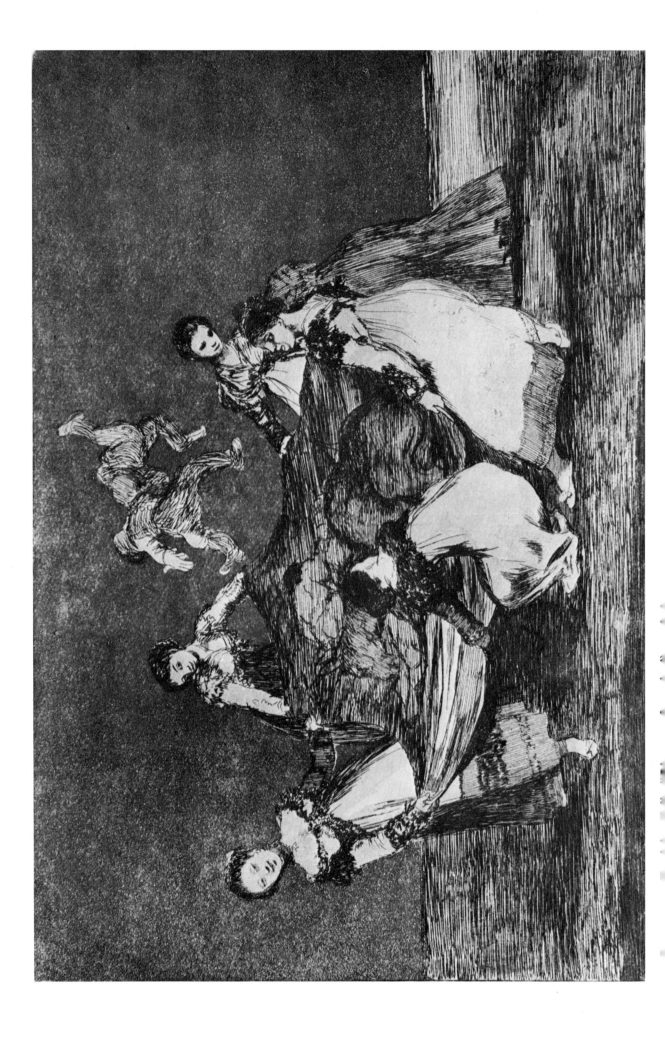

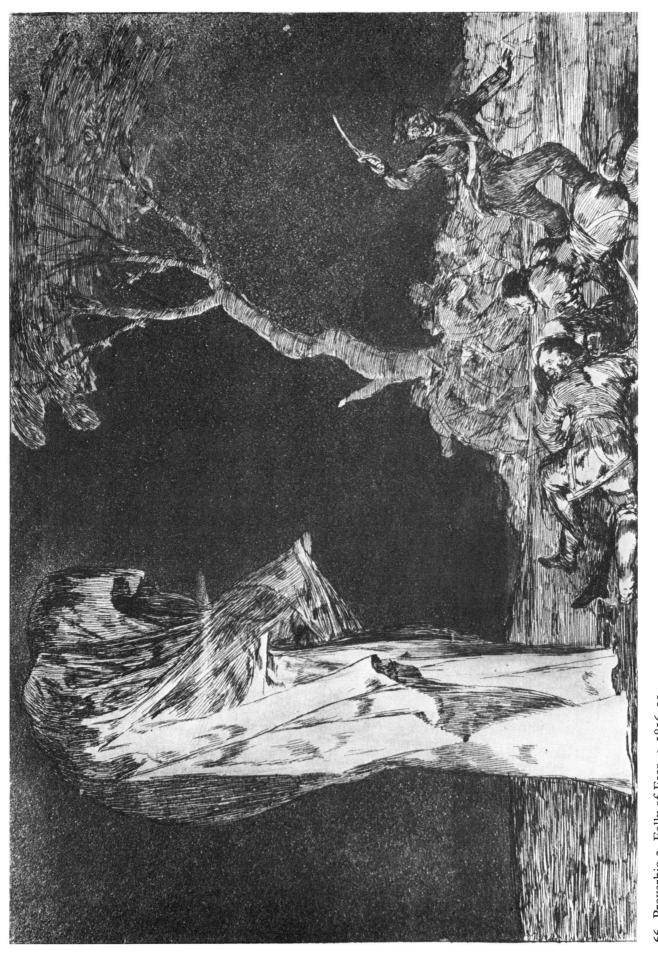

66. Proverbio 2. Folly of Fear, c. 1816–20
Etching and aquatint, 245 × 350 mm. London, Tomás Harris Coll.

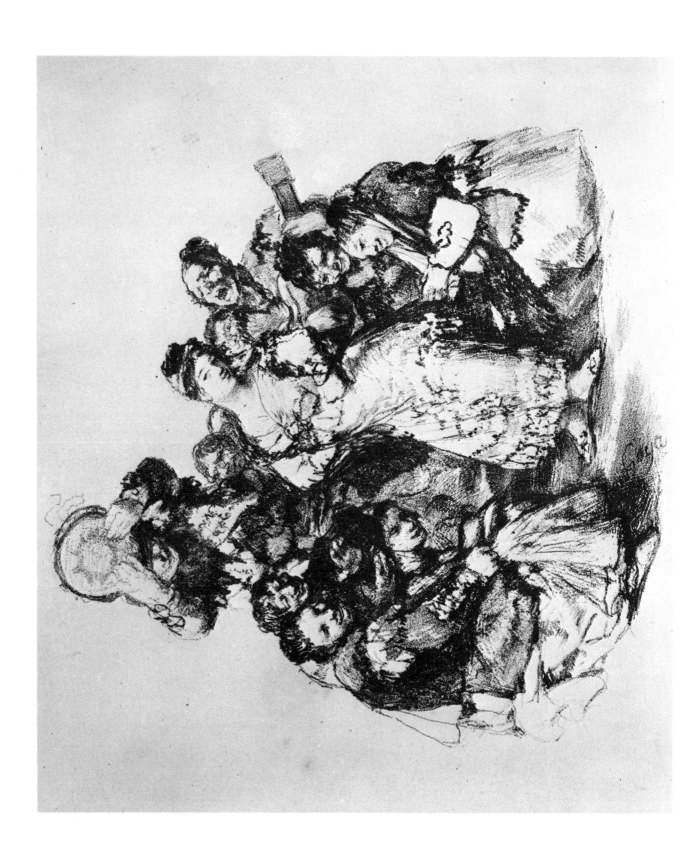

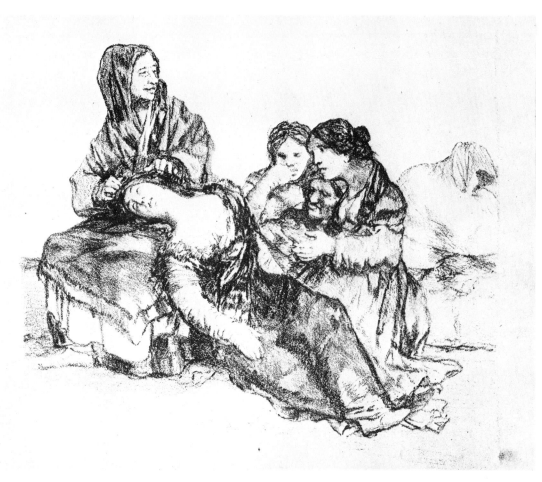

68. Group of women, *c.* 1824
 Lithograph, 130 × 160 mm. London, British Museum

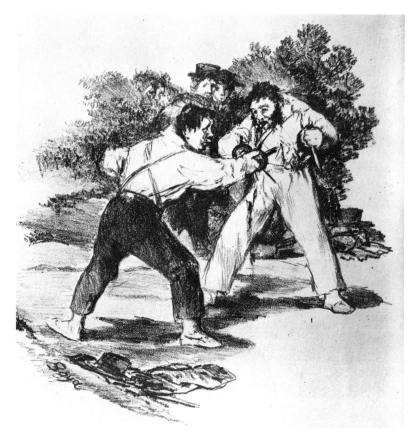

69. Modern duel, *c.* 1824
 Lithograph, 120 × 120 mm. London, British Museum

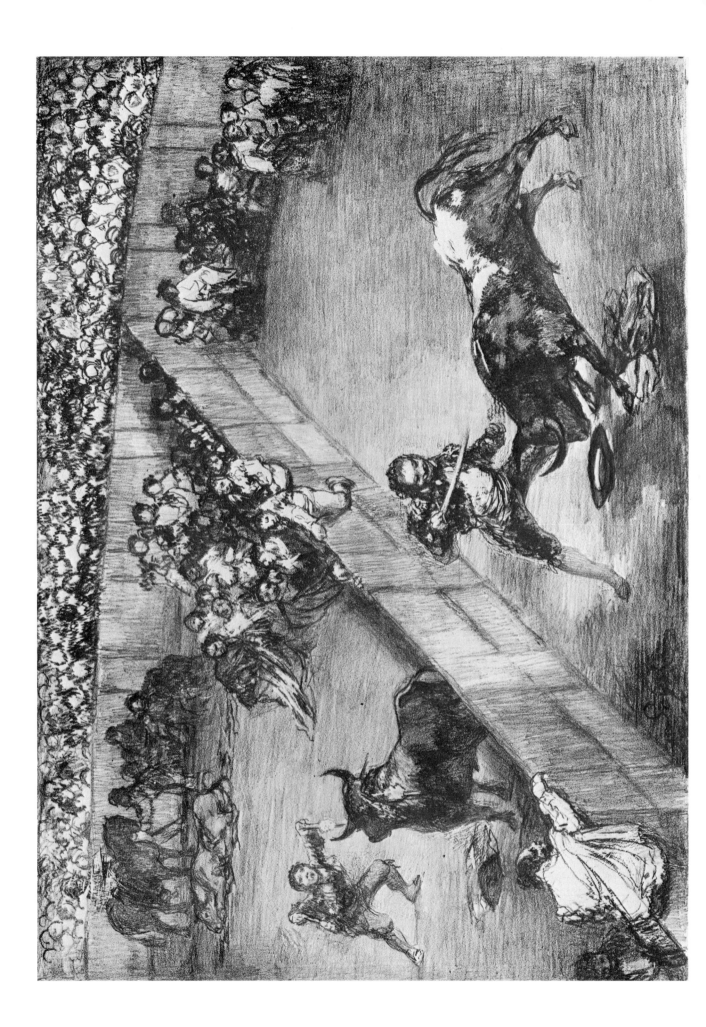

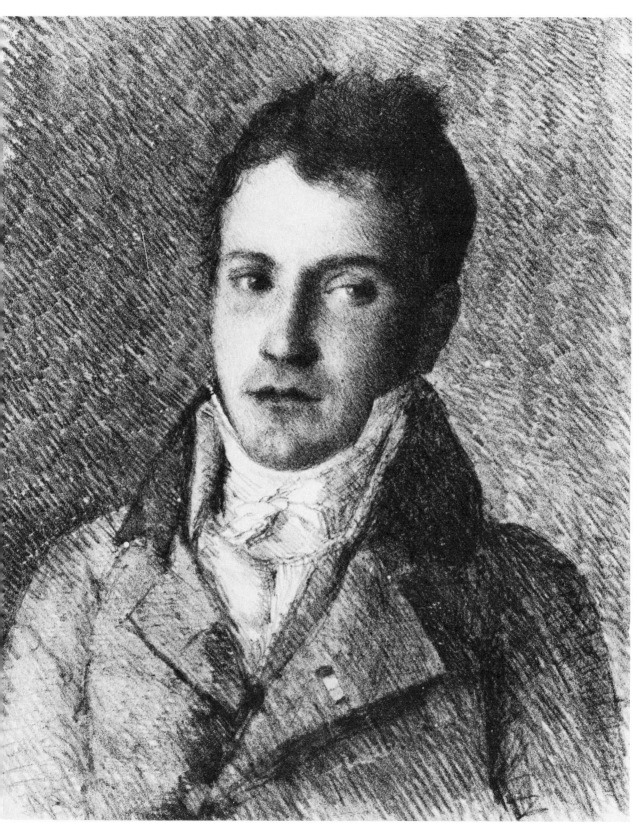

. Portrait of a young man, *c.* 1825–7
Lithograph, 220 × 180 mm. London, British Museum

Acknowledgements

The publishers wish to thank the following for permission to reproduce the works and for supplying material from which the reproductions have been made.

Berlin, Kupferstichkabinett: 43, 64
Besançon, Musée des Beaux-Arts: 14
Boston, Museum of Fine Arts: 42
Budapest, Corvina Press Archives: 13
Budapest, Szépmüvészeti Muzeum: 13
Dallas: Meadows Museum, Southern Methodist University: 7
Lille, Cliché Malaisy: 16
Lille, Musée des Beaux-Arts: 16
London, The Trustees of the British Museum: 33, 67–71
London, Courtauld Institute of Art: 44–61, 63, 65, 66
London, John R. Freeman & Co Ltd: 30
London, The Tomás Harris Collection (British Museum): 44–61, 63, 65, 66
London, The Trustees of the National Gallery: 12
Madrid, El Duque de Alba: 9
Madrid, Biblioteca Nacional: 27
Madrid, Instituto de Valencia de Don Juan: 23
Madrid, Museo del Prado: 4–6, 8, 10, 11, 17, 18, 20–22, 24–26, 28, 29, 32, 36, 37, 41
Madrid, Real Academia de Bellas Artes de San Fernando: 19
Munich, Alte Pinakothek: 15
New York, The Walter C. Baker Collection of Drawings: 1
New York, Metropolitan Museum of Art: 31, 34, 38
Ottawa, National Gallery of Canada: 39
Spain, La Duquesa de Osuna y de Gandia: 3
Washington D.C., National Gallery of Art: 2